W9-ARG-048

Watercolor Pencil
Step by Step

with Pat Averill, Barbara Benedetti Newton, and Debra K. Yaun

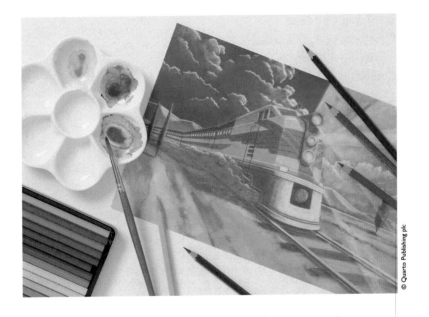

© Quarto Publishing plc

Contents

Quarto is the authority on a wide range of topics.
Quarto educates, entertains, and enriches the lives of our readers—
enthusiasts and lovers of hands-on living.
www.quartoknows.com

© 2004 Quarto Publishing Group USA Inc.
Published by Walter Foster Publishing,
a division of Quarto Publishing Group USA Inc.
All rights reserved. Walter Foster is a registered trademark.

Artwork on pages 3, 10, 18–21, 30–33, 42–45, 60–63 © 2004 Pat Averill.
Artwork on back cover and pages 10, 26–29, 38–41, 50–53, 64 © 2004 Barbara Benedetti Newton.
Artwork on front cover and pages 11, 14–17, 22–25, 34–37, 46–49, 54–59 © 2004 Debra Kauffman Yaun.

6 Orchard Road, Suite 100
Lake Forest, CA 92630
quartoknows.com
Visit our blogs at quartoknows.com

Introduction

The watercolor pencil is a truly unique artistic invention—it is literally both a drawing tool and a painting tool. This vibrant and versatile medium allows you to achieve a seemingly endless variety of effects, making it easy to render virtually any subject realistically. You can use watercolor (or water-soluble) pencils as if you were painting in watercolor, creating flat washes, transparent glazes, and blending and mixing colors on a palette. But you can also use them as drawing instruments, making opaque layers, soft gradations, and textured strokes.

Water-soluble pencils are an ideal choice for beginners, as they are easy to manipulate and offer a great deal of control. They are readily available in art supply stores and are more reasonably priced than traditional watercolor paints. And watercolor pencils—which are non-toxic—transport easily, making them ideal for traveling or sketching on site. This book will introduce you to a variety of methods and materials that will acquaint you with the medium, and you'll also discover the unique approaches of three accomplished watercolor pencil artists. Soon you'll discover that, with watercolor pencil, the only limit is your imagination!

Hilgard Camp by Pat Averill

Tools and Materials

Working in watercolor pencil doesn't require a substantial monetary investment; all you really need to get started are paper, water, a paintbrush, and a set of pencils. There are many different types of water-soluble pencil supplies on the market, but you should always try to purchase the best you can afford—better-quality pencils and paper yield more vibrant and lasting artwork.

Paper

Selecting a support (the surface on which you work) for watercolor pencil requires some thought. Because you'll be applying water to your drawing surface, it's important to choose a paper that won't buckle or warp when wet. Watercolor paper is probably the best choice, as it comes in a variety of weights and textures. The weight of the paper is indicated by a number: the higher the number, the heavier and thicker the paper. For watercolor pencil applications, 140-lb paper is a good choice. In terms of texture, hot-press paper is smooth, whereas cold-press paper has more tooth, or grain. You can also use watercolor or illustration board, colored paper, or sanded pastel paper, depending on the effect you want to achieve. (See the examples below.)

© Quarto Publishing plc

Buying Pencils Watercolor pencil manufacturers offer sets of pencils in various quantities. Unlike regular wax- or oil-based colored pencils, you can add water and mix and blend water-soluble colored pencils to create new hues. This means you won't need to purchase as many colors. (Refer to pages 12–13 for the specific colors the artists use in the projects in this book.)

Choosing a Support
In addition to the standard watercolor papers on the market, there are a number of colored papers and textured supports available. A coarse-textured paper can help you depict shaggy fur, rough bark, or grainy sand. And colored papers can provide contrast, act as a middle tone, or lend a sense of overall color harmony to your work.

© Quarto Publishing plc

Setting Up

You'll need a few basic materials to get started. Most of them are common household items you may already have, but all are easy to find at art and craft supply stores. In addition to the tools used for standard colored pencils, you'll need a few watercolor brushes of various sizes, including at least two flat brushes and a couple of small round brushes. Watercolor brushes are available with either natural-hair or synthetic bristles; both types are acceptable. Just be sure to choose brushes that bounce back into shape after each stroke (referred to as spring), and try to purchase round brushes that have well-formed points.

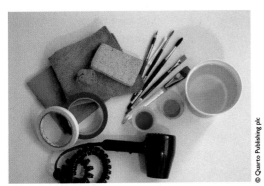

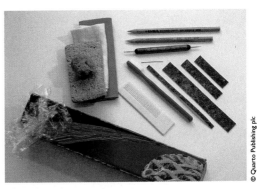

Gathering the Basics Along with brushes, you'll need a tub of water and a few small saucers for mixing colors. A couple of clean rags, a kitchen sponge, and a small silk sponge will each help you blot up extra water and create texture. A hair dryer will speed up the drying process, and drafting or artist's tape can be used for masking. A pencil extender is also handy when the pencil gets too short to hold comfortably; if your watercolor pencils are too large to fit in a standard extender, use a piece of drafting tape to secure them in place.

Creating Special Effects To create special effects in your work, there are a few extra items you'll need to have on hand. A colorless blending pencil creates a wax barrier when used with heavy pressure, so you can "seal" areas of white paper or spots of color. (See page 8.) You can use the eye end of a large needle or a stylus to impress lines in the paper, and a comb is useful for creating lines and patterns. In addition, manipulating the wet pigment with plastic wrap, rags, paper towels, sponges, or the edges of mat board can create texture in your artwork.

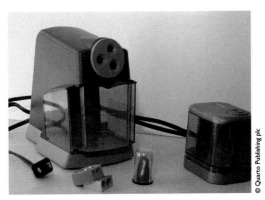

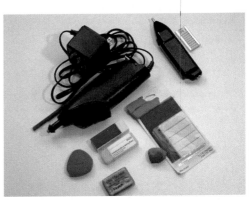

Sharpening Pencils Depending on how sharp or dull your pencil is, the line quality of your strokes will vary. But in general, you'll want to sharpen your pencil often as you work; a sharper point will yield a more even layer of color. Although a small, handheld sharpener will do, an electric or battery-powered sharpener will hone the point more quickly and cleanly.

Erasing Pigment Watercolor pencil can't really be erased, but the pigment can be lifted from the support. A regular eraser is good for cleaning up light smudges or removing graphite lines from a sketch. But to lift pigment, you can use a kneaded eraser or reusable tack. (See page 8.) And a battery-powered eraser with a plastic tip will remove color without crushing the tooth—or the grain—of the paper.

Watercolor Pencil Techniques

Watercolor pencil is very versatile, allowing you to create everything from soft, even blends to rough textures and intricate patterns. There are four basic approaches to using watercolor pencil. The first is to apply it as you would regular colored pencil and then blend the colors with a paintbrush and water. Another method is to create a "palette" by applying the pigment to a piece of scratch paper and then scrubbing a wet brush over it to pick up the color. You can also break off the tip of a sharp pencil and place it in a small amount of water to create a pool of color. Or you can dip a pencil in water until the pigment softens, rub it over the bristles of a brush, and apply the color to the support. In the following pages, you'll learn more about these methods, and you'll also discover a number of ways to make the most out of your watercolor pencils.

Strokes

When you choose a subject to render in watercolor pencil, you'll also need to determine the weight, direction, and intensity of the strokes you'll use to make the most accurate representation. Try making strokes in different directions, varying the pressure, and alternately using the point and side of your pencil. Then go a step further by blending the pigment with a damp brush—your strokes will still be apparent but softened and more diffuse.

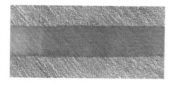

Left Diagonal Stroke You can fill in large areas with left-slanting diagonal strokes,. Here they were blended in the middle with a wet flat brush.

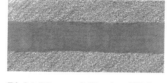

Right Diagonal Stroke This is the same example as at left but with right-leaning strokes. You'll get better coverage with this stroke if you're

Vertical Stroke This stroke can give you more even coverage, but it can be tedious. Be sure not to slant your strokes as your hand gets tired!

Overlapping Strokes You can mix colors by overlapping two hues and blending them with water. Here right diagonal strokes of green were layered over vertical strokes of blue.

Circular Strokes Straight lines aren't the only way to fill in color. On the left above, color was applied in tiny, overlapping circles. On the right, larger circles created more texture.

Bundling To create interesting texture or patterns, "bundle" small groups of linear strokes together. Note that the closer together the lines are, the more intense the resulting color.

Hatching *Hatches* are parallel lines used to suggest texture, create form, and build up color. Overlapped lines in opposite directions are *crosshatches*.

Pointillism You can also apply color with small dots made with the pencil point (called "pointillism"). The tighter the dots are, the deeper the hue.

Stippling Although *stippling* is often thought of as a brush technique, you can also stipple with a pencil; use small dots and dashes to color small areas.

Pressure

The amount of pressure you use on the pencil determines the intensity of color you produce. The more pressure you apply, the more intense the color will be. Please note that very firm pressure is not generally recommended for water-soluble pencils, as the pigment tends to clump if applied too heavily.

Light

Medium

Heavy

Gradated

Using Pressure Here you can see the difference between light, medium, and heavy pressure, as well as a gradated example—varying the pressure from left to right. The bottom half of each example has been brushed with water.

Blending

Working with watercolor pencil gives you a unique opportunity to mix and blend colored pencil pigments—you don't need to restrict yourself to overlapping layers and layers of color, as water can mix the hues. Adding water also allows you to smooth your strokes or create special effects that wouldn't be possible with regular colored pencil. Here are just some of the ways you can blend and manipulate both dry and wet watercolor pencil pigments.

Hand Blending Here dry watercolor pencil was applied with varying amounts of pressure from left to right; then the bottom was blended by hand. Make sure your hands are warm, and then use your fingers and a circular motion to blend or smudge small areas.

Tool Blending In addition to using your fingers, you can utilize tools to blend the pigment. The red lines above were blended slightly with a cotton swab (on the left) and with a paper blending stump (on the right). Both tools create smoother smudges than you'd get by hand.

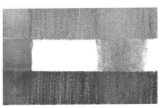

Color Mixing This example shows two wet methods for blending and mixing color: with water, as shown on the left, or with alcohol, as shown on the right. As you can see, the alcohol doesn't thoroughly dissolve all the pigment, so it produces a coarser-looking blend.

Dry Pencil In the top section, dry watercolor pencil was applied to dry paper; it looks the same as regular colored pencil. In the bottom half, the paper was wet first, and then the dry pencil applied. Notice that the lines over the wet paper appear blurry.

Wet Pencil In this example, the tip of the water-soluble pencil was dipped in water before being applied to the dry paper; then clear water was brushed down the stripe just off-center. Notice how much more intense the pigment is when wet.

Shavings This mottled texture was created by dropping pencil shavings onto the wet paper. Then, on the left side of the example, the pigment was rubbed into the paper by hand. The right side was spritzed with water to let the pigment dissolve naturally.

7

Special Effects

Once you understand the basics of working with watercolor pencil, you can begin to experiment with other tools and techniques to create different effects. Below are some ideas on ways to create texture, save white areas of color, and even remove pigment. There are an endless number of results you can achieve, so don't be afraid to play around with the methods presented here—and then invent some of your own!

Utilizing Reusable Tack To highlight by removing color in small areas, apply reusable tack adhesive or a kneaded eraser to the colored surface You can knead the tack into any shape you like; then push it onto the paper and lift the eraser to pick up the pigment.

Creating a Wax Resist You can create a wax barrier that will resist subsequent applications of wet watercolor pencil by using a colorless blending pencil. This technique is ideal for saving the white of the paper for white details and highlights, as in this example. Here a blending pencil was applied to the moon and its reflection before the watercolor wash was painted around it, allowing the "saved" areas to resist the added color.

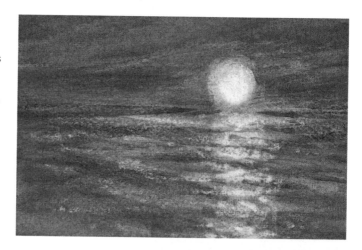

Lifting Out Color Another way to create highlights and light areas is to adapt the "lifting out" technique used in watercolor painting, as shown at right. In this example, a colorless blending pencil was applied over the colored highlights on the tomatoes and the light areas in the background. After the gray wash was painted over the entire paper (shown on the right), a clean, damp brush was stroked across the light areas several times to remove any residual gray. Note that, for this technique to be effective, the brush must be cleaned and dampened for each additional swipe.

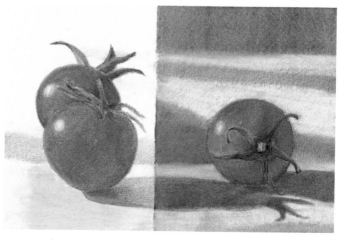

Starting Simply Some colored pencil artists begin by laying in the values of darks and lights in their subject; this method is called "grisaille." Although this term usually refers to a black-and-white value study, it can also be used to describe any color value base that will be overlaid with more color. As pigments are layered over the study, the initial darks lend additional depth to the darkest areas of the subject. In this example, the left side shows the value study drawn with both graphite and regular colored pencil. On the right, water-soluble pencils have been layered on top to complete the scene.

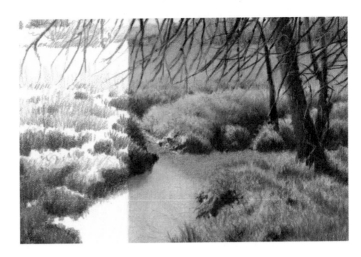

Masking

Masking is a great way to save white areas, to create clean, straight edges, or to protect one colored area from subsequent layers of color. There are a number of ways to mask effectively, including using low-tack artist's tape, masking film, and masking fluid. Tape is ideal for creating crisp straight edges, and masking film is clear, making it easy to fit around the elements in your design. Removable masking fluid is meant as a temporary barrier, to be gently rubbed off when no longer needed. Permanent liquid masking fluid remains in place. It can be colored before being applied or left white to save the paper color, but be aware that it has a shine when dry.

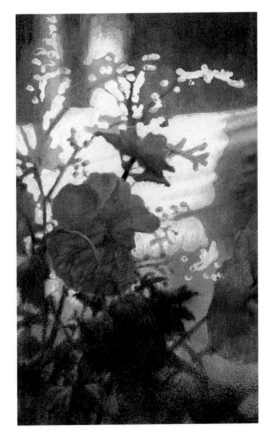

Using Removable Masking Fluid In this example, removable mask was used to save the white areas. Use an old paintbrush to apply the mask (it will ruin a good brush), and gently remove the mask with a rubber cement eraser when your additional layers are completed and dry. Don't leave it on longer than 48 hours, or it will be very hard to remove.

About the Authors

Pat Averill

Although she considers herself primarily self-taught, Pat Averill has attended an array of workshops and seminars in oil, watercolor, and colored pencil. She considers the way she figuratively "inhales" the colors, values, and shapes she observes around her to be an integral part of her artistic process. To her, the creation of art is based on a combination of life experiences and the artist's reaction to the subject matter. Pat is a charter member of the Colored Pencil Society of America, and she has won numerous awards in juried international exhibitions for her work in colored pencil.

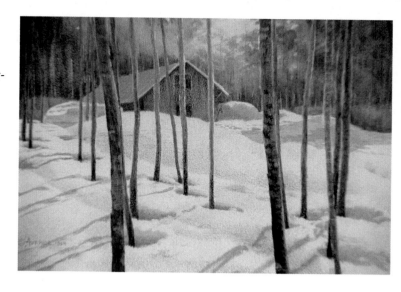

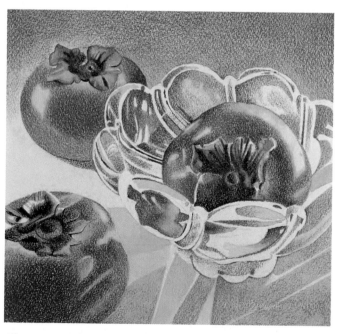

Barbara Benedetti Newton

Barbara Benedetti Newton's formal art career began as a fashion illustrator, but 20 years later she began creating fine art in colored pencil. She is a Charter Member, a Signature Member, and a past national President of the Colored Pencil Society of America. Her award-winning paintings are expressions of spare elegance and relationships: color to form, object to subject, shadow to light. After more than a decade of working exclusively in colored pencil, Barbara's recent work includes mixed media and pastel. Barbara teaches art workshops to all skill levels throughout the Northwest, including classes at the Frye Art Museum, in Seattle, Washington.

Debra Kauffman Yaun

A graduate of the Ringling School of Art and Design in Sarasota, Florida, Debra K. Yaun began her art career as a fashion illustrator and graphic designer. Later she discovered a book on colored pencil in a library and fell in love with the medium. Now she stays busy with portrait commissions and nature drawings. As time allows, she teaches an occasional art class, and her artwork has been published in several art magazines and books. Debra is a juried member of the Portrait Society of Atlanta, and she is also a member of the Colored Pencil Society of America.

11

Color Palettes

Every artist has a group of favorite colors and brands they prefer working with; below are the colors the artists use for the projects in this book. Keep in mind that the names of the colors may vary among brands; sometimes two pencils that have the same name are two different hues—or two pencils with different names might be the same hue.

Black	Black cherry	Blue-gray	Blush pink	Brown ochre
Canary yellow	Carmine red	Cedar green	Chocolate	Cold gray V
Cool gray 30%	Copenhagen blue	Crimson red	Dark green	Dark umber
Deep cobalt blue	Flesh	Flesh pink	Gold ochre	Golden brown
Goldenrod	Grass green	Hooker's green	Imperial purple	Indigo
Indigo blue	Lemon yellow	Light carmine	Light cobalt blue	Light orange
Light phthalo blue	Lilac	Madder carmine	Magenta	Mineral green

12

Note: The colors shown here are for general color reference only. Although great care has been taken in the production of this book, the printing process has limitations, so some colors cannot be replicated with complete accuracy.

Moss green	Night green	Ochre	Olive green	Orange
Oriental blue	Peacock blue	Peacock green	Pink madder lake	Pompeian red
Poppy red	Raw sienna	Rose madder lake	Sap green	Scarlet
Scarlet lake	Silver gray	Sky blue	Spanish orange	Spring green
Sunburst yellow	Terra cotta	True blue	Ultramarine blue	Van Dyke brown
Violet	Warm gray 30%	Warm gray 70%	Warm gray 90%	Warm gray V
White	Wine red	Yellow	Zinc yellow	

Focusing on Flowers

with Debra K. Yaun

Flowers make beautiful and interesting artistic subjects; no matter the variety, flowers have a timeless and classic visual appeal. And if you're looking for a good subject to start with in watercolor pencil, flowers are an excellent choice. You can use the painterly effect watercolor pencil offers to render the soft, translucent quality of blossoms and foliage. But you can also utilize the fine points of dry pencils to define the intricate details of petals and leaves. In this example, Debra K. Yaun uses both dry and wet watercolor pencils to render two simple flowers against a plain, dark background, creating strong contrasts and a dramatic finished piece.

Simplifying the Subject Sometimes the best way to approach a subject is to "zoom in" with your camera. To capture the simple beauty of these colorful amaryllis blossoms, I cropped in closely, eliminating the unnecessary details in the background.

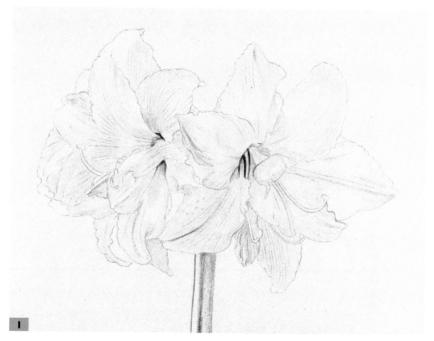

Step One First I carefully draw the flowers on hot-press watercolor paper with a graphite pencil. I indicate where the veins in the petals are to help give them shape. Next I lightly layer indigo over the shadow areas and on the veins in the petals. Then I shade the stem and the centers of the flowers a little darker with indigo.

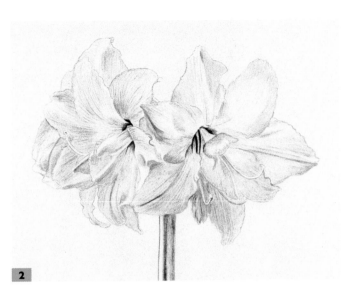

Step Two Next I use a medium round watercolor brush to apply a light wash of water over the blue areas. Then I add madder carmine to the dark centers of each flower and layer sunburst yellow over the indigo in the centers. I also add a little sunburst yellow to a few outer petals to indicate reflected color from the centers. I use crimson lake to lightly fill in most of the petals, but I leave the lightest areas and the yellow centers untouched.

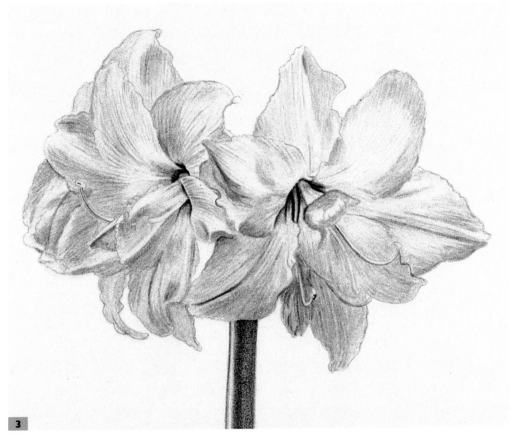

Step Three Now I stroke water over the petals with a medium round brush, pulling the water from the center of each flower out and along the veins. I add a layer of olive green over the indigo on the stem, leaving a lighter area for the highlight on the left side. Next I use grass green on the stem and reapply indigo over it. I add a wide stripe of grass green next to the indigo and then layer spring green over the yellow in the center of the flower.

15

Step Four I use crimson lake for the outline and dots on the petals, varying the size and density of the dots to make the pattern random. I use a dry pencil on dry paper to add these details, but if you want a more intense color, you could apply the pencil to damp paper. Keep in mind that the pencil dissolves a little when it touches the wet surface, so take care not to tear the paper.

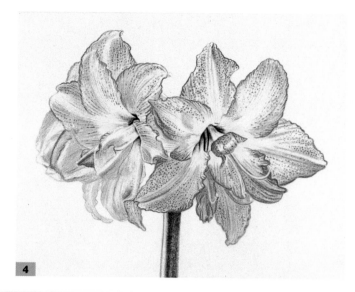

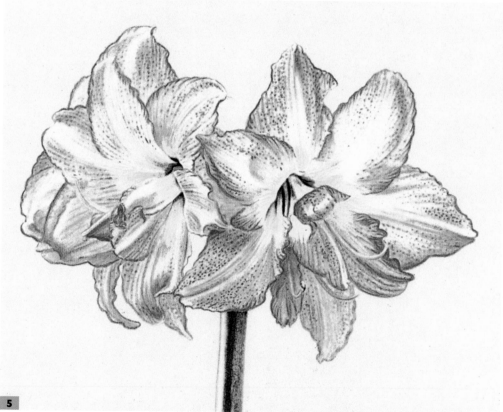

Step Five I finish the pattern on the petals, and then I add a little imperial purple to darken the shadows in the petals. Then I use a brush and clean water to soften and blend the dots, centers, and edges of the flower petals. Next I create the pollen detail at the ends of the stamen with sunburst yellow and terra cotta. I look at the reference photo often to make sure that I'm capturing the detail accurately. Now it's time to create the background; I need to choose a color that won't detract from or conflict with these bright flowers, as I want them to stand out as much as possible.

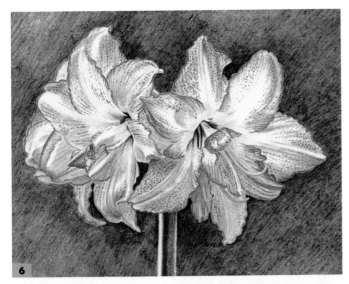

Step Six I cover the entire background with a layer of indigo, adding madder carmine and imperial purple here and there for interest. Then I use a large flat brush and apply clean water to the biggest areas of the background, causing the colors to blend. Next I switch to a smaller brush for the areas that touch the petals.

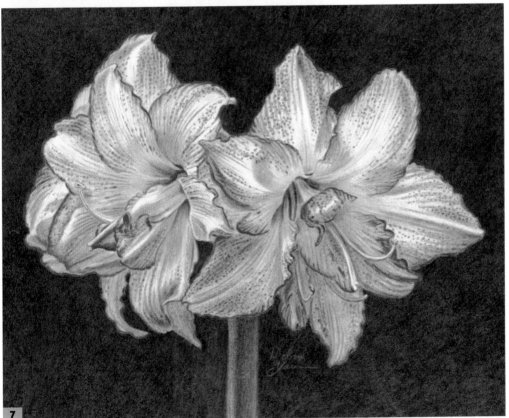

Step Seven Now I use a smaller brush to smooth the purple shadows and the centers of the flowers. I add crimson lake along the edges of the wet petals, and then I dip the tip of the crimson lake pencil in water and add a few more bright spots along the edges of the petals. I also apply more grass green to the stem and centers, and I add another light layer of indigo to the stem. I decide the background needs to be darker, so I add more indigo, blending it with water. Then I go back and define the edges of the stamens with violet, also applying more grass green to the stem. I add more indigo to the top of the stamen and layer some violet and grass green in a few areas of the background to help tie in the colors of the stem. Finally I darken the background a bit more, using a circular motion to layer chocolate brown over the existing color.

17

Conveying Depth

with Pat Averill

Nature offers a wide range of intriguing and colorful scenes that almost beg to be captured on paper. But to accurately translate a three-dimensional scene onto a two-dimensional support, it's important to include a few simple visual cues that will create a sense of depth in your watercolor pencil drawings. For example, you can vary the size of the objects in a scene, as larger objects tend to appear closer while smaller objects appear farther away. You can also convey the illusion of depth by varying the intensity of your colors according to the rules of *atmospheric perspective;* the particles in the atmosphere make objects in the distance appear lighter and cooler in color, more muted in value, and less detailed than objects in the foreground. And to help emphasize the feeling of depth, try to establish a distinct background, middle ground, and foreground, as Pat Averill has done in this colorful tulip field. Pat uses many methods of establishing depth in this scene: She varies the sizes of the trees; she uses bright, warm colors in the foreground and cool, grayed tones in the background; and she reserves the most detail for the flowers in the front.

Step One First I mask off a border with masking tape on 140-lb hot-press watercolor paper. Then I place drafting tape next to the outside edge of the border, taping down each edge completely so the paper is sealed to a flat drawing surface. (This will keep the paper from warping when water is added.) I draw the horizon line, and then I make a cross to plot the height and width of my center of interest, or *focal point:* the large stand of trees on the horizon line. I place a few additional tree trunks of various heights, and then I draw several horizontal lines to establish the foreground, middle ground, and background. I also add some dashed diagonal lines to guide the placement of a few brightly colored flowers, which will help direct the viewer's eye to the focal point.

Step Two Next I create a "palette" of deep cobalt blue and cold gray V. (See page 21.) Then I wet the sky from top to bottom with clean water and a large flat brush. I rub the wet brush over the palette colors, creating a cool gray mixture, and quickly brush this color across the sky. I lift the brush where no color is desired, and I am careful not go over any area twice. When the sky is dry, I use scarlet to draw small oval flowers, starting at the horizon. As I work toward the foreground, I make the flowers progressively larger. I use the same technique to add more flowers with canary yellow, and then I "save" some white flowers in the foreground by covering them with a blending pencil.

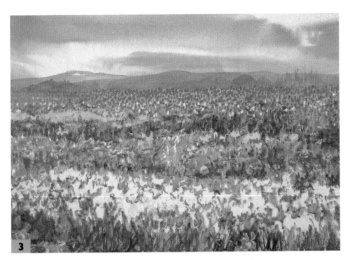

Step Three I dampen a medium flat brush, pick up the blue-gray mix from my palette, and brush it across the distant hills. Then I dip a sharpened olive green pencil into water and draw the tulip leaves. To create the green bushes and small trees, I touch the tip of the olive green pencil to my wet brush and stroke the color at the horizon. When everything is dry, I "polish" the flowers with a soft cloth to remove any paint residue. Next I replenish some of the bright flower colors with more scarlet and canary yellow. Then I use a battery-powered eraser to remove any excess pigment from the white flowers in the foreground.

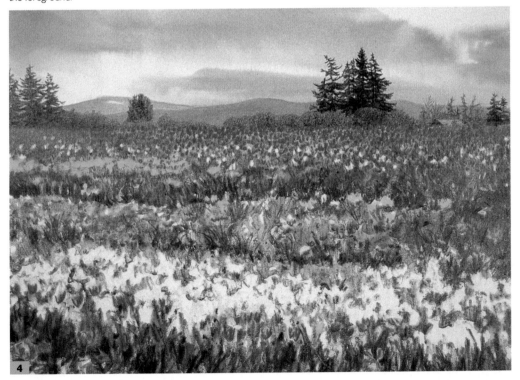

Step Four I switch to regular colored pencils to create the trees at the horizon, using peacock green and scarlet. Then I layer the same colors in the small clumps of trees and the building. Next I apply a light layer of scarlet over the distant hills, and I add peacock green to the greenery between the rows of flowers in the distance. Below this, I apply peacock green with short vertical strokes to depict leaves, making longer strokes as I approach the foreground.

19

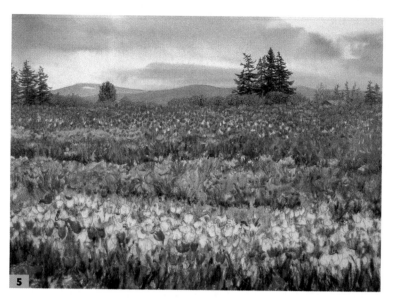

Step Five Next I add canary yellow to the small clumps of trees, and then I use a battery-powered eraser to lift out some color from the tops of the distant red flowers. I apply light orange to the top portion of the red flowers and to the lower part of the yellow flowers, using firm pressure and a short diagonal stroke, and I reapply scarlet to the red flowers with firm pressure. Then I loosely scribble canary yellow in the area of the green leaves, and I outline the white flowers with scarlet, starting at the lower edge and working up.

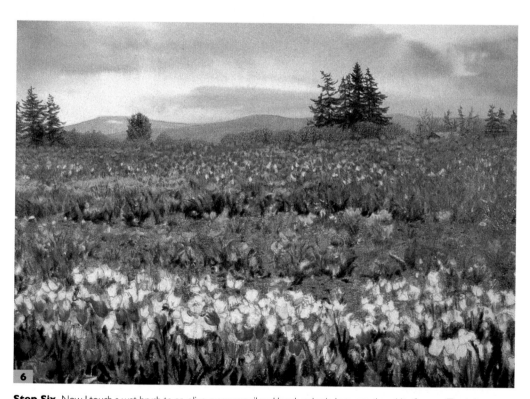

Step Six Now I touch a wet brush to an olive green pencil and brush color in between the white flowers. To darken the base of the leaves, I apply scarlet and then peacock green, using heavy pressure and a right diagonal stroke. Next I use a combination of scarlet and deep cobalt blue to depict the dirt between the rows of flowers, using medium pressure and a horizontal stroke. I add some additional dirt areas, using the battery-powered eraser to remove unwanted pigment. Then I mix scarlet and peacock green to make dark shadows, adding dark specks in the dirt for variation.

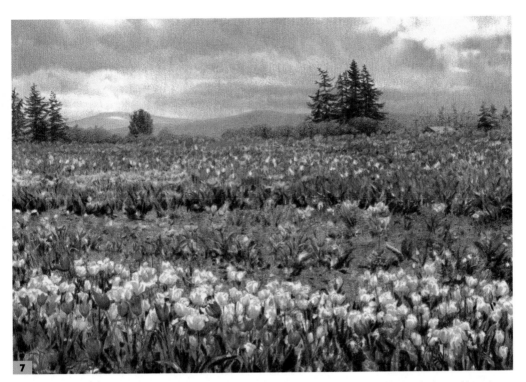

Step Seven With regular colored pencils, I follow the contours of the white flowers and create shadows with a mix of scarlet and cool gray 30%. I layer light orange over the base of the white flowers, applying light pressure. Then I use a battery-powered eraser to help restore the whites in the flowers; I also use the eraser as a drawing tool to create some leaf patterns in the green shadows. To make crisp edges on the white flowers, I outline them with olive green. Then I add layers of peacock green and scarlet over the shadows in the foreground red flowers. I layer cool gray 30% and deep cobalt blue to darken the clouds slightly, using a vertical stroke. Finally I use white to add a few sparkling highlights on the leaves.

Creating a Palette

If you're using traditional colored pencil, you can't actually mix the colors; you have to rely on layering and burnishing to "mix" new hues. But with watercolor pencil, you can create a palette with a piece of frosted acetate. (The acetate must be frosted on at least one side so the dry color can stick to it.) Tape dry acetate to a flat surface, and scrub on small patches of dry watercolor pencil. Then liquefy the pigment with clear water and a brush. This acetate palette won't absorb color, and it can be rinsed off and reused.

Artwork by Barbara Benedetti Newton.

21

Working from Photos

with Debra K. Yaun

Working on site and drawing from life is ideal, especially with watercolor pencils, as they are easy to transport and utilize outdoors. But using photographs in place of live models has some advantages too. You don't have to worry about inclement weather or shifting light, and you can be sure that your subject won't change position as you work. Once you find a subject that inspires you, take snapshots of it from different angles and viewpoints to make sure you have a comprehensive range of reference photos. Then, when you return to your studio, you can compare the various shots to find the most inspiring one to draw from. Here Debra K. Yaun uses a photo reference to render a colorful tropical bird as it preens.

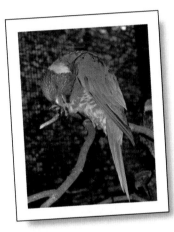

Using Artistic License I use photo references for almost all my work, but that doesn't mean I copy exactly what I see in each photo. When an artist alters the reference to create a more pleasing scene, it's called "taking artistic license." In this case, I decide to add some leaves behind and below the bird to help the composition and to add interest. I also decide to adjust the branch the bird is perched on, open up the eye a little more, and leave the bands off his legs.

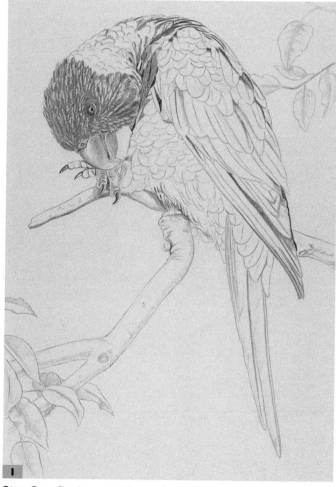

Step One First I use a graphite pencil to draw the bird on hot-press watercolor paper. Then I apply ultramarine blue to most of the head, the dark feathers on the body, and the shadows in the leaves. I also use indigo to indicate the shadowed edge, as well as the knots and rough areas of the branch. Next I apply crimson red to the outer eye, part of the beak, and a few feathers.

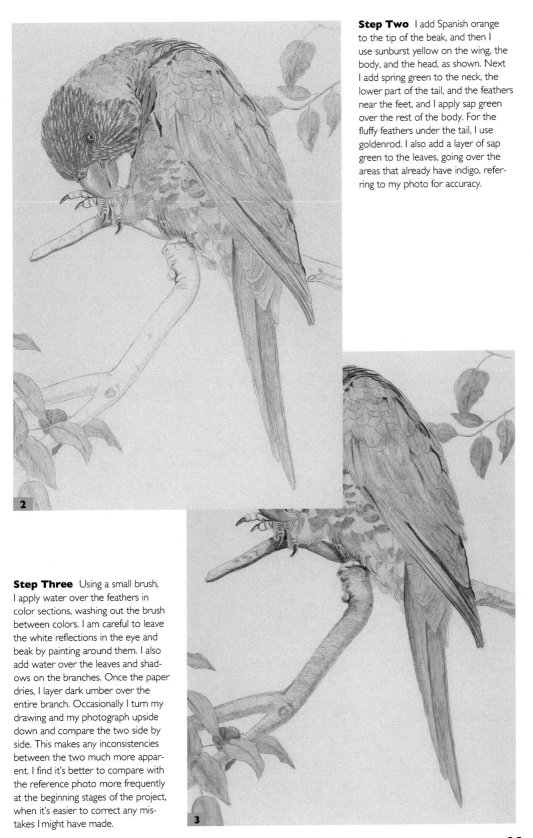

Step Two I add Spanish orange to the tip of the beak, and then I use sunburst yellow on the wing, the body, and the head, as shown. Next I add spring green to the neck, the lower part of the tail, and the feathers near the feet, and I apply sap green over the rest of the body. For the fluffy feathers under the tail, I use goldenrod. I also add a layer of sap green to the leaves, going over the areas that already have indigo, referring to my photo for accuracy.

Step Three Using a small brush, I apply water over the feathers in color sections, washing out the brush between colors. I am careful to leave the white reflections in the eye and beak by painting around them. I also add water over the leaves and shadows on the branches. Once the paper dries, I layer dark umber over the entire branch. Occasionally I turn my drawing and my photograph upside down and compare the two side by side. This makes any inconsistencies between the two much more apparent. I find it's better to compare with the reference photo more frequently at the beginning stages of the project, when it's easier to correct any mistakes I might have made.

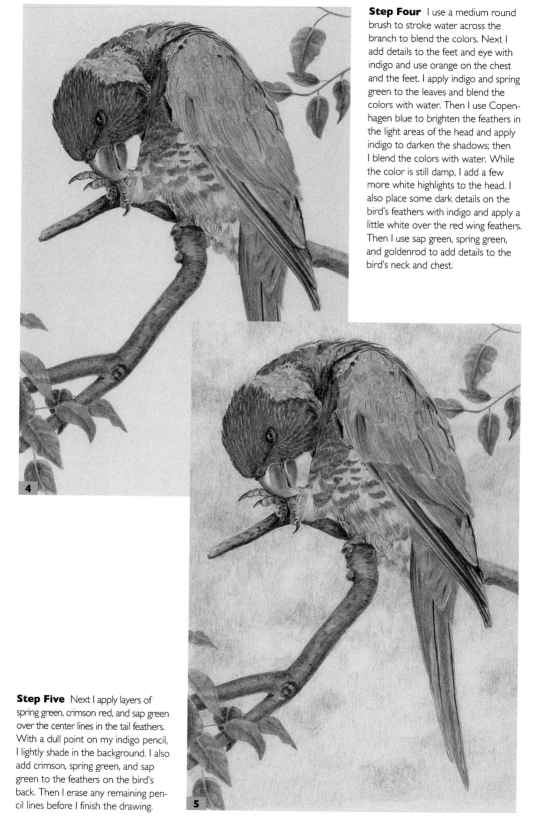

Step Four I use a medium round brush to stroke water across the branch to blend the colors. Next I add details to the feet and eye with indigo and use orange on the chest and the feet. I apply indigo and spring green to the leaves and blend the colors with water. Then I use Copenhagen blue to brighten the feathers in the light areas of the head and apply indigo to darken the shadows; then I blend the colors with water. While the color is still damp, I add a few more white highlights to the head. I also place some dark details on the bird's feathers with indigo and apply a little white over the red wing feathers. Then I use sap green, spring green, and goldenrod to add details to the bird's neck and chest.

Step Five Next I apply layers of spring green, crimson red, and sap green over the center lines in the tail feathers. With a dull point on my indigo pencil, I lightly shade in the background. I also add crimson, spring green, and sap green to the feathers on the bird's back. Then I erase any remaining pencil lines before I finish the drawing.

24

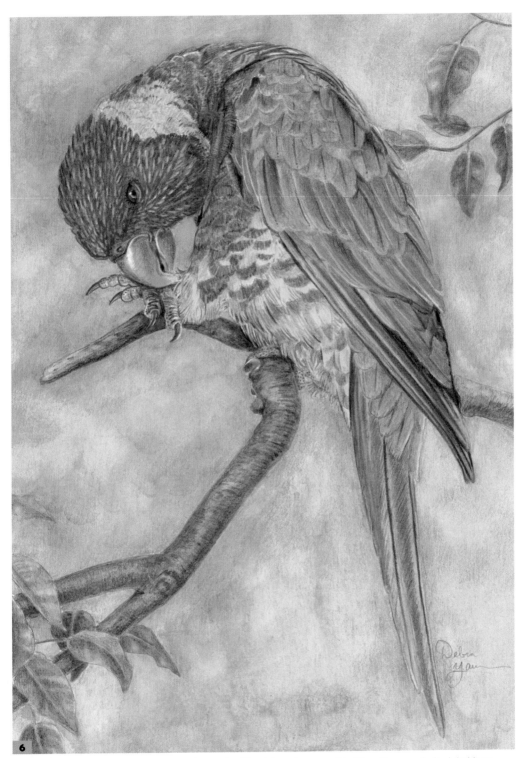

6

Step Six Now I brush water over the background to blend the colors smoothly. Once the paper is dry, I decide to apply indigo to a few areas that need a smoother transition from light to dark. I also use imperial purple to add some more detail to the feathers, and I build up a little more color in the feathers with spring green and mineral green. Finally I redefine a few lost edges on the feathers by scraping off the color with a utility knife, being careful not to tear the paper as I reveal the underlying white paper. Now I am pleased with my final drawing.

Composing a Still Life

with Barbara Benedetti Newton

Unlike rendering a landscape you discover in nature, drawing a still life gives you a great deal of control over the objects you portray. You can arrange the elements any way you like, and the lighting can be natural or artificial and strong or diffused, depending on the effect you want to achieve. Setting up a still life also gives you the opportunity to work with a variety of shapes and a wide range of watercolor pencil colors in one setting. To set up a lively still life, be sure to include objects of various sizes, and consider pairing complementary colors. For example, in this still life drawing, Barbara Benedetti Newton juxtaposes diverse and colorful shapes—including the cool violet ribbon against the complementary warm yellow lemons—to create a beautiful, vibrant arrangement.

Step One Once my initial sketch is complete, I use lemon yellow to loosely fill in the flowers, the lemons, and the area behind them. I leave some paper uncolored along the edge of the foremost lemon to indicate highlights and a "halo," showing that it is strongly backlit. Then I wet a brush, stroke a lemon yellow pencil over it, and paint in the two stems in the upper right of the painting. When the area is dry, I wet the pitcher with a clean, damp brush. Working quickly, I wet my brush again and stroke the tips of both dark green and indigo-blue pencils to load my brush with color. Then I touch the tip of the loaded brush to the puddle of clear water in the pitcher area, letting the colors run.

Step Two I let the painting dry completely before moving on. I fill in the ribbon with a dry violet pencil and then use a small watercolor brush and clear water to liquefy the pigment. While the ribbon is drying, I sharpen my violet pencil, break off the tip, and place it in a small amount of warm water, where it will dissolve into a wash. Then I use a brush to apply this wash to the cast shadows, to the area behind the pitcher handle, and to the lower-right corner of the painting. I also add some of the violet wash to the pitcher and the glass dish beneath the pitcher. I repeat the wash where I want a darker value, always letting each layer dry between applications to avoid lifting off color.

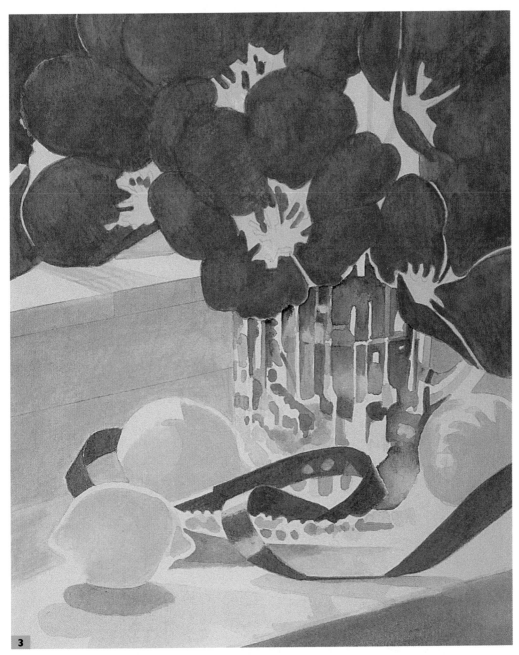

3

Step Three Next I fill in the flowers with poppy red, placing the strokes close together and making them as uniform as possible. Then I wet the poppy red flowers with a brush and clear water to blend the strokes. While the flowers are drying, I sharpen the poppy red pencil, break off the tip, and dissolve it in warm water. I add more water as necessary to dilute it to a pale red color. Then I wash this pale red over the lemons, carefully painting around the highlighted areas. I also apply the same red wash to the area behind the two lemons on the left, as well as in and under the glass plate to show the red reflections from the flowers. When all my foundation colors are complete, I carefully erase any remaining graphite lines with a soft plastic eraser.

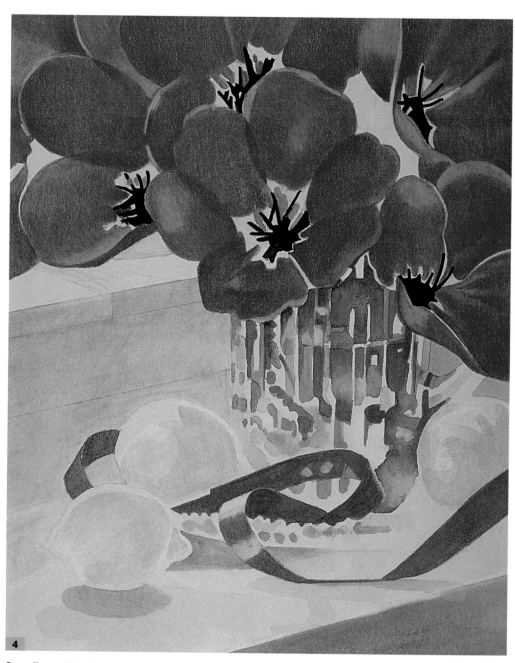

4

Step Four Although other artists work differently, I like to save the painting and coloring of the main subject until last. This way, I make sure I give the background and all the other peripheral elements in the setup the care and attention they deserve before moving on to the main subject. Now I start to build the form and volume of the poppies by applying more dry poppy red on each petal to create a consistent texture. I add white to the areas that are lighter in value than my foundation color, and I apply crimson red in darker areas and wine red for the darkest values. Next I add black to the centers of each flower, and then I solidify and darken the pigment by stroking clear water over the area with a small watercolor brush.

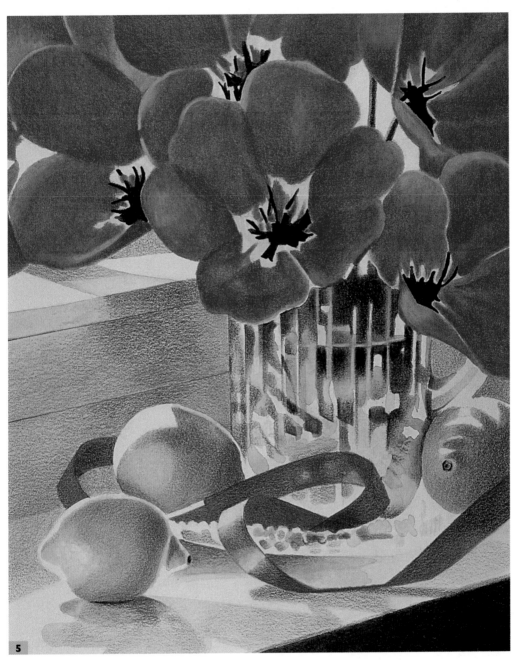

5

Step Five Next I apply indigo blue and dark green to the two flower stems in the upper right of the painting, and I enhance the water line on the pitcher with white pencil. I apply indigo blue, violet, dark green, ultramarine blue, and a little black to the darkest areas of the pitcher; then I add layers of indigo blue, violet, and ultramarine blue to the ribbon. I darken the background and the cast shadows from the lemons and ribbon with indigo blue, violet, and true blue. For the reflections from the red flowers, I apply dry poppy red. Next I build up color on the lemons; I start with wine red and then add layers of sunburst yellow, poppy red, and violet. To complete the painting, I add dry black pencil in the lower-right corner and brush over it with clear water. When the color is completely dry, I apply dry black, wine red, and indigo blue on top.

Understanding Perspective

with Pat Averill

If you've ever looked out across the ocean at the line where the sky seems to meet the water, you've observed the horizon line. When drawing a landscape, the horizon is always the first line you establish. If you place it high in the picture plane, you will emphasize the foreground of your scene, whereas if you place it low, you will focus on the sky. And when an object like a road or a fence recedes into the distance, its retreating lines appear to converge at a single point on the horizon called the vanishing point. (See the diagram on page 33.) This is an example of one-point perspective, because all the receding lines meet at one point. In this landscape by Pat Averill, the background trees obscure the horizon line, but you can still picture where the vanishing point is at the end of the road. The perspective in this scene also creates an engaging composition; the high horizon line emphasizes the country road, which draws your eye into the scene and toward the focal point—the light at the end of the road.

Step One First I draw a border on 140-lb hot-press watercolor paper with a soft graphite pencil. As always, I use drafting tape to seal the edges of my paper to a flat surface so it won't buckle when I add water. I start by determining the focal point of my scene—in this case, it's a patch of light at the end of the road. Next I create a simplified line drawing of the sides of the road, the wet areas in the path, the dark trees, the patches of sunshine on the foreground pavement, and the small sign. I use dashes to help separate the masses of different values in the trees.

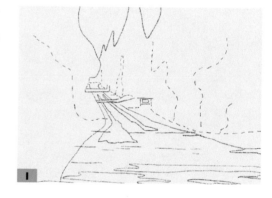

Step Two To "save" the lightest values, I create a waxy barrier that the watercolor pencil won't be able to permeate by firmly covering those areas with a colorless blending pencil. These areas include the end of the road, portions of the sign, the brightly lit leaves, the dirt, and the spots of sunlight on the pavement. Next I use a canary yellow regular colored pencil to fill in the spots of yellow throughout the scene, using dots or short diagonal strokes and firm pressure. Then I repeat the process for the red leaves, using a scarlet regular colored pencil.

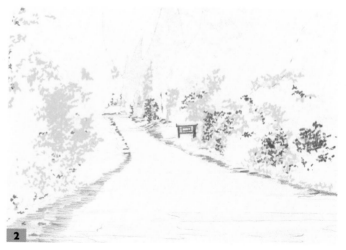

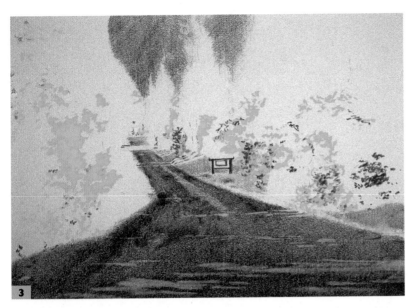

Step Three Now I use water-soluble pencils to create the distant hills and the road. First I apply warm gray V, then deep cobalt blue, and finally light carmine. Before I began this piece, I made a quick value sketch to determine where the darkest and lightest values are in this scene. Now I refer to my value sketch to accurately place the shadows on the road.

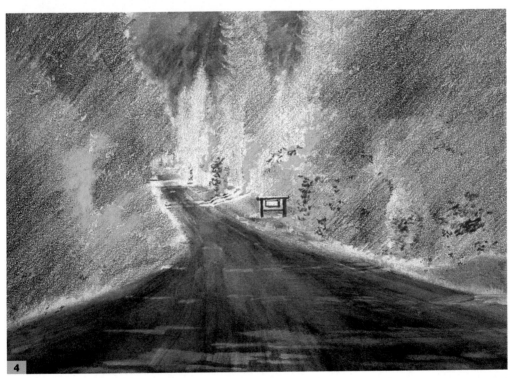

Step Four With a wet brush, I dampen the edges of the distant hills to keep them soft. Then I wet the brush again and quickly stroke over the hills to dissolve the pigment. Starting at the widest part of the road and working up, I repeat the same process, stroking up over the existing gray pigment with a damp brush to enhance the sense of perspective. When the paper is completely dry, I sharpen a deep cobalt blue pencil and apply it over the trees and grass, using little pressure in light areas and firmer pressure in darker areas. Then I go over the same area with vertical strokes of canary yellow.

Step Five I dampen a medium flat brush and wet the lightest tree values first; then I move on to the darker areas in the trees. When it's nearly dry, I take a clean, damp brush to lift off excess paint from the areas where I used the blending pencil and regular colored pencil. Then I go over everything (except the sign) with a plastic eraser to remove any remaining color on the lightest values. Now I use regular colored pencil to create some dark values. I use a combination of dark green and scarlet to block in the dark areas in the trees, the dirt, and the sign, using short diagonal strokes. In the bright green areas, I use only dark green (no scarlet).

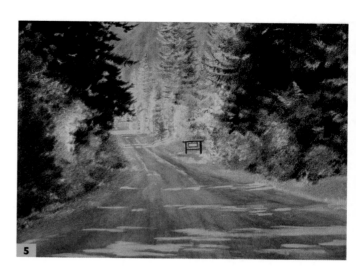

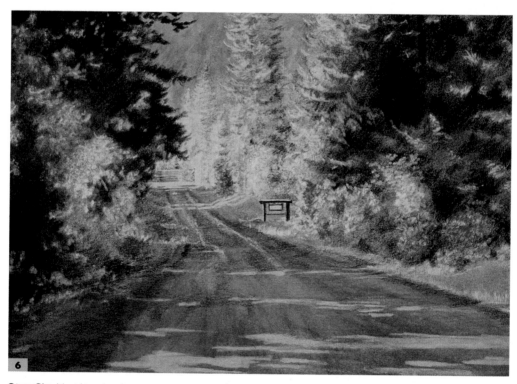

Step Six Next I touch a sharp moss green watercolor pencil to a wet brush and then stroke it on the green trees and grass to brighten them. Then I use warm gray V in the same manner to darken the edges of the road. When the paper is completely dry, I use a battery-powered eraser to remove excess paint from the light areas. To create the sunlit leaves, I make small circular strokes with canary yellow, followed by scarlet. I also make some horizontal strokes with scarlet to indicate the dry fir needles beside the road. Then, with a sharp indigo-blue pencil, I darken the sides and center of the road near the sign.

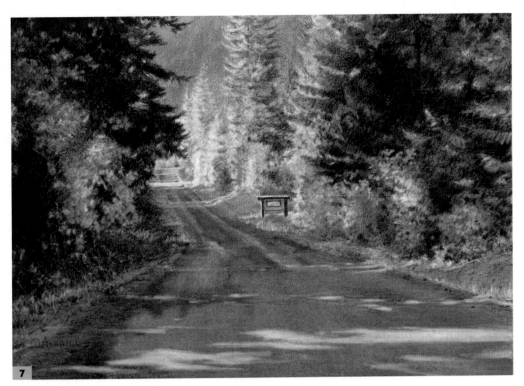

Step Seven Now I apply vertical strokes of deep cobalt blue on the distant hills and in the road. Then I go over the road and the dirt with scarlet, comparing my work to my photo reference for accuracy. I use dots, scribbles, and diagonal strokes of black cherry in the darkest values throughout the painting, and I use a blending pencil to blend the colors in the road. To complete the sunlit patches in the road, I use a battery-powered eraser to remove excess pigment. Some of the spots appear to be too long or too big, so I repair them with a combination of indigo blue and scarlet, then I blend the colors in the road with a blending pencil. Next I apply white over the sunlit patches and the tire tracks on the road. To complete the painting, I refresh some of the yellows, reds, and greens with a little more color.

One-Point Perspective

In this diagram, you can see how all the lines of the house, the road, and the trees recede into the distance and converge at one vanishing point (VP) on the horizon. The side of the house that's facing us is the closest plane to us, and its bottom and top edges are parallel to the horizon line (HL). The guidelines demonstrate how the rest of the lines that recede into the distance eventually converge at the vanishing point. If two planes are involved, such as the building viewed from one corner in this example, each plane has its own vanishing point. This is referred to as *two-point perspective*. To make sure the perspective in your drawing is correct, try placing a ruler on any line that's retreating into the distance and make sure it leads to the vanishing point. For more on perspective, see *Perspective*, also in the Artist's Library Series.

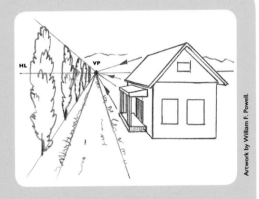

Artwork by William F. Powell.

33

Rendering Animals

with Debra K. Yaun

Once you've experimented with watercolor pencils a bit and become familiar with the types of effects you can achieve, you can practice drawing a wide variety of subjects. Animals are appealing for many reasons. For example, their actions and expressions can be touching, amusing, and even humanlike at times. In addition, animals provide the opportunity to experiment with techniques for rendering different types of hair and fur—from short and coarse to long and silky. For this animal portrait, Debra K. Yaun uses a variety of colors and watercolor pencil techniques to depict the soft, velvety fur of two adorable rabbits.

Finding a Focus Although my photograph has a perfectly acceptable composition, I want the focus of the scene to be on the charm of these cuddly rabbits. So I decide to alter some elements in the photo. I sketch it out on a piece of scratch paper first, simplifying the composition a bit by leaving out the cage and the chicken and substituting a different bunch of carrots.

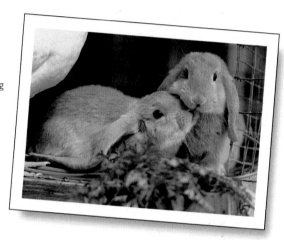

Step One I cover the back of the sketch with graphite, place the graphite side on cold-press illustration board, and trace over the lines. To keep from smudging the pencil lines and to protect the board from the natural oils on my hands, I place an extra sheet of paper under my drawing hand. Then I start blocking in the shadows, applying a layer of blue-gray in the lighter areas and indigo in the darker areas of the fur. I fill in the eyes with indigo, leaving the white highlight. I also use indigo to add the shadow for the wood and the background. Then I apply blue-gray for the shading on the carrots and indigo for their cast shadows.

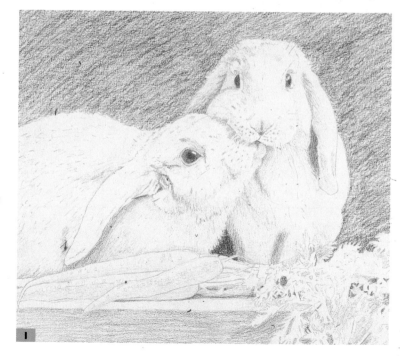

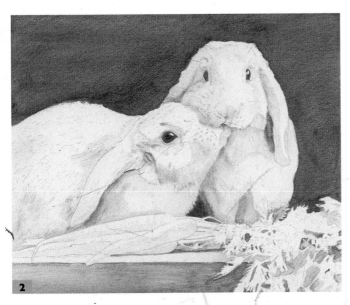

Step Two Using a medium round brush, I apply water to the background and to the dark wood under the bunnies. I switch to a small brush for the smaller areas. I also wash out my brush between colors, occasionally wiping my brush on a paper towel to remove any excess pigment. Then I add a shadow to the rabbit's ear near the carrots with a little of the blue-gray left on my brush. Once the background is dry, I apply dark green over it all.

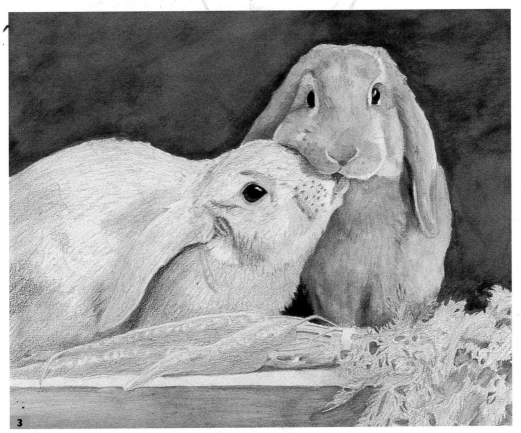

Step Three Now I brush water over the background with a medium round brush. I apply chocolate to the eyes and then smooth them with water. While the color is still wet, I add black to the pupils but leave the highlights white. To add a "glow" in the eyes, I apply golden brown to a few places around the bottom of the eye. Then I add sky blue to the highlights in the eyes. Next I apply a base color of Van Dyke brown to most of the fur (except the lightest areas), also adding chocolate to some of the dark areas and under the ears. I use a small brush to apply water over the rabbit on the right, and then I apply a base coat of cedar green to the carrot tops, adding a little dark green for shadows. Then I fill in the carrots with orange.

35

Step Four Using a small brush, I apply water to the left rabbit. Then I use a clean wet brush to soften the carrots and carrot tops, leaving the highlights untouched. When the water dries, I use scarlet lake on the dark parts of the carrots. Then I layer Van Dyke brown over the wood beneath the carrots, stroking over the indigo wash but leaving the edge white. Next I apply more indigo to the lower background and use chocolate to indicate a few small dark areas of fur. Then I lightly apply goldenrod to warm and lighten most of the fur.

Step Five Now I blend the strokes in the brown fur using a small brush and water. Then I add Van Dyke brown to indicate some darker creases and shadows on the bottoms of the carrots. I use Oriental blue to add some color to the white under the rabbits' jaws. Then I add sap green to the carrot tops to define some individual leaves and apply indigo to define the dark areas more clearly. Next I add details in the fur with short strokes of golden brown and Van Dyke brown.

6

Step Six Now I soften the white fur by stroking Van Dyke brown into the white. Then I blend the edges of the fur by pulling some of the dark green background color into the fur. I also create some details on the rabbits' faces with raw sienna and then add a few white whiskers. I use a damp brush to smooth the carrot tops, and I add strokes of flesh to indicate the fur on the edges of the rabbits. I use chocolate for the wood grain beneath the rabbits, and then I apply water to blend the browns. I use a damp, stiff nylon brush to blend the edges and highlights on the carrots. I also add some orange and Van Dyke brown to the shadows on the carrots, and then I apply some spring green and white strokes to define the edges of the carrot tops. Next I add Oriental blue to the carrot tops and blend it in with a damp brush. Finally I use silver gray to soften some areas in the background and darken the area behind the carrot greens with indigo.

Creating Backgrounds

A simple way to create a smooth background is to apply dry pencil to dry paper and then blend the pigment with a wet brush. But you can also create even washes of color by "painting" with the pigment. Dip a sharp pencil in water until the color begins to drip, rub the point over a flat brush, and apply it to the paper. For lighter areas, like the ones in the example at right, dampen the paper before you brush on the color.

Artwork by Pat Averill.

Depicting Glass

with Barbara Benedetti Newton

Glass adds an interesting element to a still life. Glass both reflects light and allows light to pass through it, creating strong contrasts of light and dark and a range of vivid colors. Although accurately rendering glass may seem intimidating, drawing it is no different than depicting any other subject—just look for the basic shapes and try to draw only what you really see. In this case, Barbara Benedetti Newton breaks down a blue glass bowl into simple shapes and values to make it easy to render the colorful reflections and cast shadows.

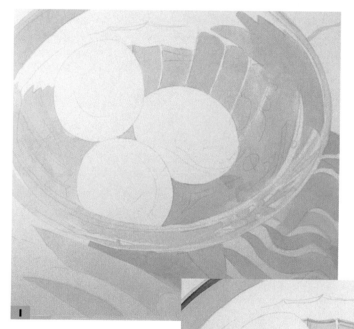

Step One After sketching a line drawing on stretched watercolor paper, I create a "palette" of true blue on a piece of frosted acetate. (See page 21.) I dip a medium angled brush in the liquified pigment and carefully apply color to the bowl, painting around the eggs. I fill in most of the bowl and the cast shadow reflections, being careful to avoid the areas I want to remain white.

Step Two Once the first wash is dry, I apply dry ultramarine blue to the acetate palette. (Whenever I'm done using a color on the palette, I rinse off the palette and let it dry before applying another color.) With a small, wet watercolor brush, I add dark blue details to the bowl. For larger areas, I switch to a larger brush. I don't need to follow my line drawing exactly; instead I take my cues about where the values are darkest and lightest from my reference photo. For darker areas, I add a small amount of water to the color on the palette; for lighter hues, I add more water.

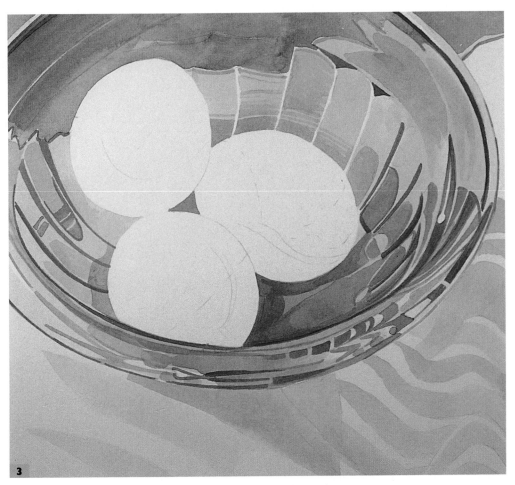

3

Step Three Next I scrub patches of ultramarine blue and sap green onto my frosted acetate palette. With a small angled brush, I wet the two colors and mix them together. For the areas of the bowl overlapping the white tablecloth, I use an equal portion of each color; but for the green background and the places where it shows through the bowl, I add more sap green. The wash doesn't have to be perfectly even because I will apply dry colored pencil over it to smooth out the color. When the painting is dry, I erase any remaining graphite lines (except those inside the eggs) using a white plastic eraser.

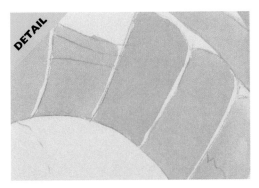

Glass Stage One Detail I build up the reflections in the glass one layer at a time, starting with the lightest areas. I allow each layer to dry before moving on to the next one, sometimes using a hair dryer to speed the drying process.

Glass Stage Two Detail With each layer, I add progressively darker values, carefully imitating each shape that I see. The shapes of the different reflections will estab- lish the form of the glass bowl.

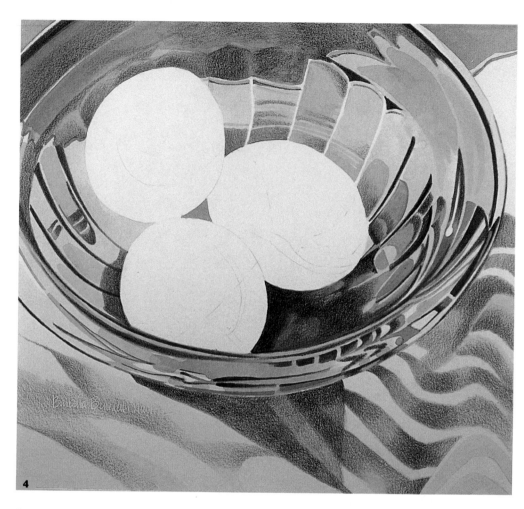

4

Step Four Next I sharpen indigo blue and black pencils and alternately layer the two colors in the darkest areas of the bowl. While working with these two pencils, I place a slip-sheet under my hand to keep the white areas clean. I also lightly apply the same two colors to the cast shadows on the tablecloth and for the medium values in the bowl. Then I use reusable adhesive (see page 8) to lift some of the dry color in the lightest areas of the bowl and to soften the cast shadows.

DETAIL

Signature Detail Usually the last thing artists do is sign their piece; but in this case, I'm going to create a kind of "reverse" signature, so I need to do it before my final applications of color. First I place a small piece of waxed paper (wax-side down) in the lower-left area of my painting. Then I firmly write my name on the waxed paper with a medium-point (not fine) ballpoint pen. This creates an impressed line on the watercolor paper that also has a wax coating, which will make my signature resist color when I apply wet or dry pencil over it.

40

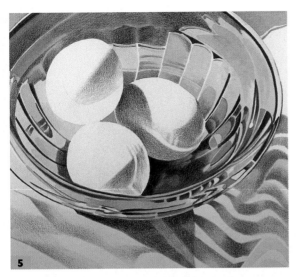

5

Step Five To color the soft shadows on the eggs, I use dry layers of wine red, ultramarine blue, gold ochre, and true blue. I start each egg with a layer of wine red, as shown on the egg on the left, holding the pencil at the back end and applying the color lightly. Then I add a layer of ultramarine blue, as shown on the egg in the foreground. Next I apply layers of gold ochre and true blue, as shown on the egg at the right. Then I add wine red to the green wash behind the eggs and to the darkest areas of the painting to warm the color.

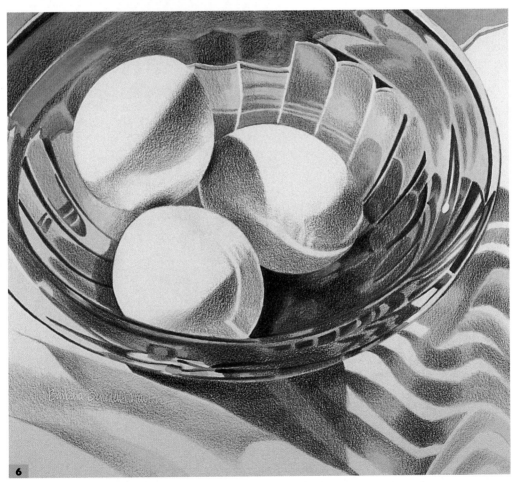

6

Step Six To finish the painting, I apply ultramarine blue and true blue to the bowl and the cast shadows. Then I apply white to the bowl for the reflection behind the egg on the left. I also add a small amount of indigo blue to the dark areas where the top egg touches the other two. Finally I clean up any smudges of color on the white eggs by dabbing them with reusable adhesive.

41

Drawing a Seascape

with Pat Averill

The ocean can be mesmerizing; the regularity of the tide can lull even the most anxious observer into a calm and relaxed state. But the sea can also be dramatic; pounding surf and choppy waves are exciting to watch. For these reasons—and many others—seascapes are popular subjects for artists. They are also ideal for beginners: The horizon line is easy to discern, the composition is usually fairly simple, and the elements can be minimal. In this example, Pat Averill creates a dynamic composition by placing the diagonal lines of the rocks, the wet sand, and the dark horizon line so that they form a Z pattern, drawing the viewer's eye into and around the picture. For added interest, she includes two huddled surf watchers as the focal point of the scene.

Step One I like to make a simple drawing on copy paper before I transfer it to a good-quality watercolor paper. When my line drawing is done, I tape it to a bright window, and then tape 140-lb hot-press watercolor paper over it; the light allows me to see through to the sketch beneath. I use a #2 graphite pencil with light pressure to trace the design, and then I seal the edges of the paper to a flat working surface with drafting tape.

Step Two To "save" the lightest values, I apply a blending pencil to create a barrier that will resist subsequent applications of color. I cover the white foam of the waves, the plastic bag hanging from the woman's coat, and several light areas of the sand. I use dots, dashes, and tiny lines to render the highlights of the crashing waves. Next I create a "palette" with swatches of deep cobalt blue, cold gray V, and Pompeian red. I wet the sky with a damp rag until it has an even sheen.

Then I rub the rag into the deep cobalt blue and cold gray V from my palette and wipe the color across the sky. Once the sky is dry, I load a wet small brush with deep cobalt blue, a touch of Pompeian red, and cold gray V to paint the ocean at the horizon. I stroke back and forth, rewet the brush, and cover the rest of the ocean. Then I reload the brush with blue and wash color over the water. When it's dry, I wet the rest of the paper evenly and load a medium brush with Pompeian red and cold gray V to fill in the sand. Then I use a damp brush to remove excess paint from the white waves.

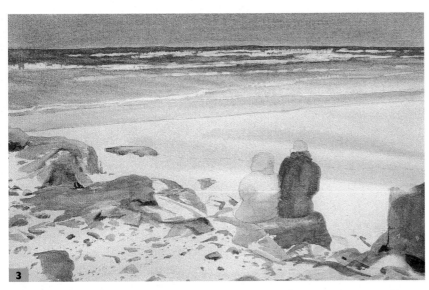

Step Three Next I dampen the strip of wet sand and brush cold gray V and Pompeian red across it. I use the same mix for the rock shapes, brushing color into the dark areas first and then adding another layer of color. I load my medium flat brush with deep cobalt blue, a touch of cold gray V, and Pompeian red to paint the man's coat and hood. Then I dampen the man's hair and the woman's coat and brush on a mixture of Pompeian red with a touch of cold gray V.

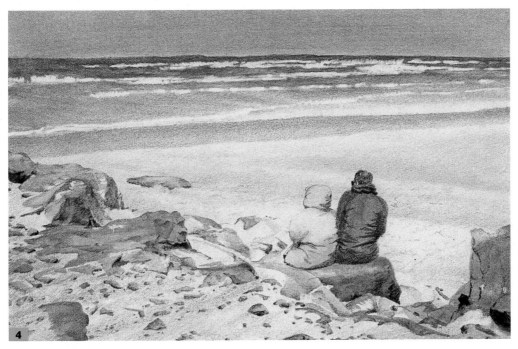

Step Four Now I put away my water-soluble colors and use regular colored pencils. I rub a plastic eraser over everything except the figures to remove any remaining graphite pencil lines. On the sky and the shallow water, I add a light tint of pink with a magenta pencil. I lift unwanted color with tack and then rub it horizontally into the paper surface with my finger. I accent the dark water with night green, using medium pressure. I use the same color over the shallow water but lighten the pressure. Next I apply warm gray 30% to the wet sand with medium pressure and a right diagonal stroke. I layer the same color using a slightly dull point and light to medium pressure to make details in the dry sand. To develop the dark values, I use warm gray 90% in the rocks, the coats, and the man's glasses and hair. I outline each area first with a very sharp pencil, and then I fill in the shapes.

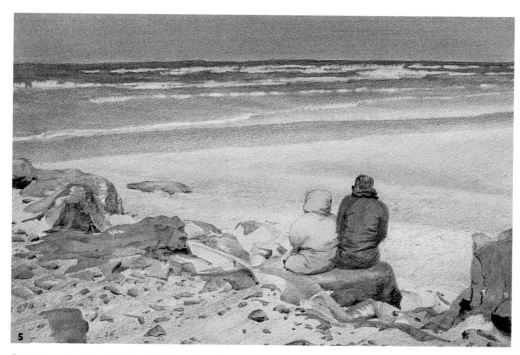

Step Five Next I apply light cobalt blue to the sky and water, using light pressure and avoiding the areas I want to stay white. Then I use warm gray 70% to make short, left diagonal strokes in the water near the horizon, creating some dark areas directly under the waves. I outline the man's coat with a sharp light cobalt blue pencil first; then I use heavy pressure in the shadows and light pressure on the highlights to fill it in. I use the same blue to add a touch of color on some of the rocks and rock shadows and to fill in the woman's coat. Then I use light cobalt blue to add a touch of color to the wet sand.

Fabric Detail To capture the soft texture of the man's windbreaker, I pay careful attention to the folds in the fabric. Once I have outlined and filled in the area, I go back with the same color and accent the creases, using firm pressure to create the appearance of folds in the material.

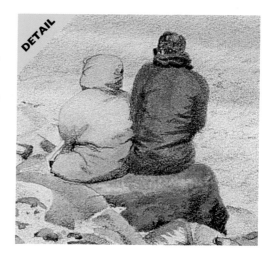

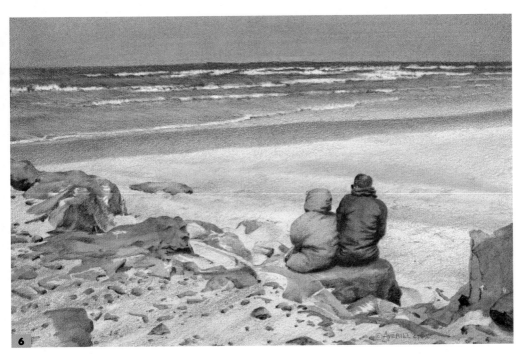

Step Six I outline on the woman's coat with magenta and then fill it in with light pressure and vertical strokes. I use firmer pressure in the folds of the fabric, and then I add magenta to the man's coat to show some reflected color. I place a few short strokes of magenta to the man's hair. Then I add a few magenta lines in the rocks and add some of the same color to the wet sand, the distant water, and the depressions in the dry sand. I use canary yellow to loosely cover the magenta areas in the sand and to add yellow to the foreground rocks. To complete the piece, I finish painting the water. (See detail below.)

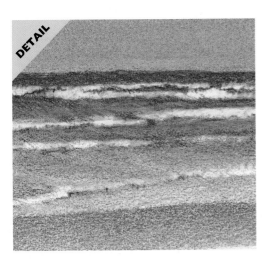

Water Detail For the water near the horizon, I stroke on a little canary yellow. Then I add some white reflections under the crashing waves and in the distant water. Finally I add a few shadows under some of the waves, using dots and dashes with a sharp warm gray 70%.

Portraying Children

with Debra K. Yaun

Renderings that capture the charm of young children seem to have a universal appeal. This could be because we like to look at the world through a child's eyes or because we can all appreciate the innocent curiosity reflected in their faces. In any case, it can be incredibly rewarding to portray a child in your artwork. Try to choose a pose that will focus on some of the features that illustrate their innocence: big, wide-set eyes, rounded features, and a relatively short, small nose. In this example, Debra K. Yaun emphasizes the rosy cheeks and blond, tousled curls of Marlee, creating a lovely informal portrait of a young child exploring the world.

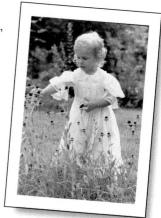

Copying a Reference To be able to capture a good likeness, I need to be sure my sketch is accurate. To keep the proportions of the girl correct, I use the grid method to create my drawing. First I draw a grid onto a small piece of tracing paper and place it over the photo. Then I lightly draw a proportionate grid on my support and copy the lines over, one square at a time.

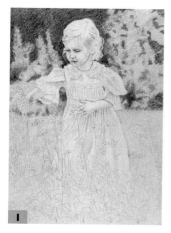

Step One I choose a pale yellow sanded pastel paper for this piece to complement the scene and to provide a good midtone for the portrait. Once my sketch is in place, I completely erase the grid I used to transfer the drawing. Then I lay in the darkest areas of the background with indigo and lightly shade in the rest with the same blue. Next I use blue-gray to lightly fill in the shadows on the little girl's dress, face, arms, mouth, and eyes.

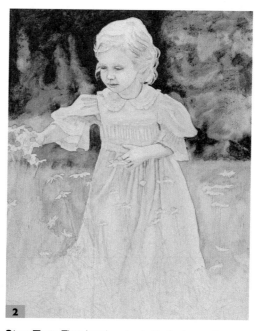

Step Two Then I apply water to the background, starting with the darkest areas. I also blend the skin, dress, and lower background with a wet brush, making sure to rinse the brush between color areas. Then I paint over the flower stems and centers, but I leave the lightest areas untouched.

Step Three Now I apply mineral green and cedar green to the upper background, grouping the colors and blending them in places to indicate the bushes in the distance. Then I use brown ochre to lay in a base color for the skin and to add some color to the hair. Next I apply a few strokes of chocolate to the darkest areas of the hair and use sap green for the lower background and the flower stems. I also add golden brown to a few areas of the background, over the existing green, and blend it in with a wet brush, allowing the colors to run together.

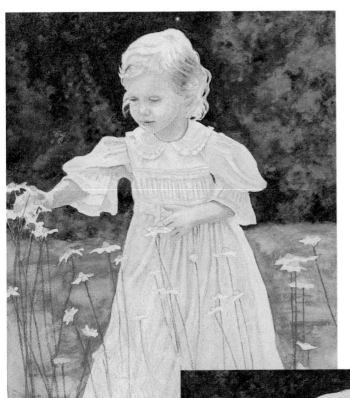

Step Four Next I place violet and lilac in the deep creases and shadows of the dress. I also lightly apply violet to the neck, chin, and shadowed areas of the arms and lightly add pink madder lake to the face. I shade the edges of the bushes with indigo to redefine their shapes. Then I use mineral green over some of the leafy areas, adding some true blue for extra color. Then I reestablish the stems and indicate some leaves on the flowers with sap green.

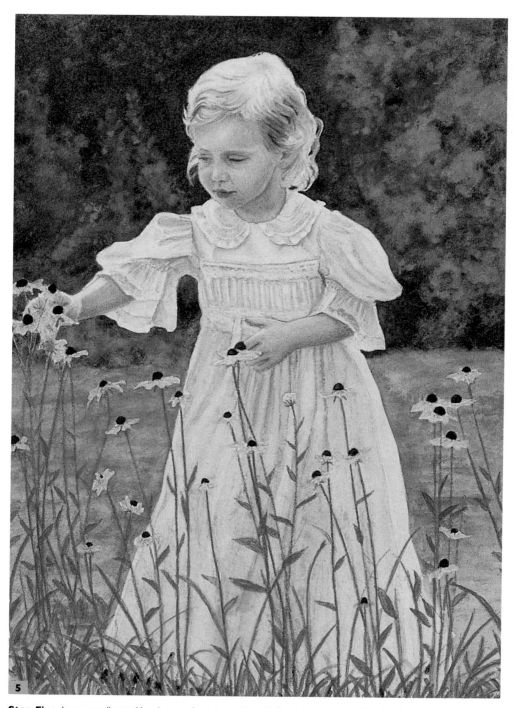

5

Step Five I use a small round brush to apply water to the girl's face, hair, and arms. Then I switch to a medium round brush and apply water to the dress, painting around the flowers and some of the stems. Next I use goldenrod and then spring green on the lower background to indicate grass, and then I soften those areas with a damp brush. I also apply chocolate to the centers of the flowers and stroke over them with a small damp brush. When they're dry, I add a small amount of terra cotta to the centers of the petals, and then I stroke sunburst yellow on the petals as well. I add pink madder and then terra cotta to the lips and soften them with a damp brush. Next I add Van Dyke brown to the hair, the neck, and the cheek. Then I lightly apply pink madder lake, goldenrod, and imperial purple to the skin in the more shadowed areas.

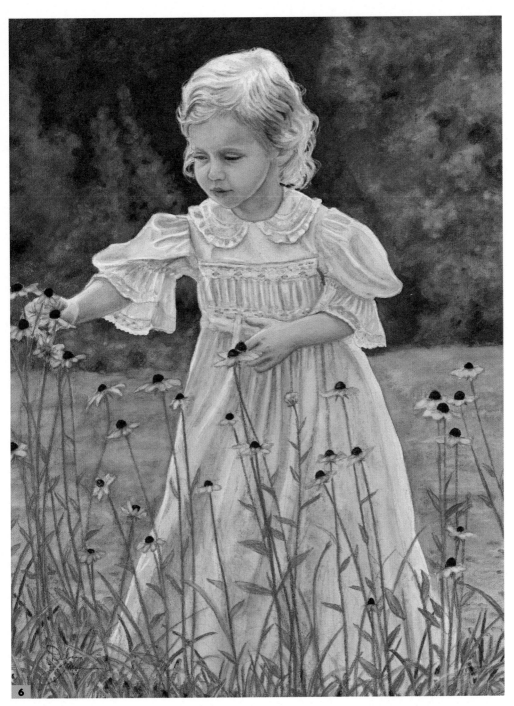

6

Step Six With a wet brush, I stroke from the end of each petal into the center. I add a few more dark green leaves at the bottom and soften the area with a damp brush. After adding a few more leaves with mineral green, I layer zinc yellow over some and sky blue on others. Then I use sky blue and spring green in the upper background. I add a few spots of blush pink and sunburst yellow to the dress, which I then soften with a wet brush. I wet the face with a clean brush; when it's dry, I add more flesh pink. Next I define the edges of the dress with white and some wisps of hair. I add a little more imperial purple to the arms and use flesh pink to smooth the arms and hands. Next I smooth the dress with sky blue, and I add mineral green to the edges of the outstretched hand. I layer spots of Van Dyke brown in the background to indicate some ground. For final touches, I use a blending stump to smooth a few rough spots on the girl's skin and dress.

Creating the Appearance of Texture

with Barbara Benedetti Newton

Including various textures in a still life not only creates more visual interest, it also makes your subject more entertaining to draw because you can use a different technique for each texture. Rough textures may require dry, short, choppy, overlapping strokes, while smooth textures typically involve long, even strokes and soft blends with a brush and water. One of the best ways to practice drawing different textures is to set up a still life composed of objects that have a variety of surfaces: smooth glass, silky ribbon, shiny metal, or a rough woven basket are all possibilities. In this clever setup, Barbara Newton contrasts the uneven skin of the ripe strawberries with the smooth surface of the china plate and the delicate lace doily, creating a unique and beautiful scene.

Step One First I create a line drawing on stretched watercolor paper. Then I sharpen a canary yellow pencil to a long, tapered point using a battery-powered pencil sharpener. I break off the point and place it in 2 tablespoons of clear, warm water, where I leave it to dissolve into a yellow wash. Then I apply the wash to the berries with a medium round brush. I'm careful to leave most of the leaves and any highlights on the strawberries uncolored. I let this step dry completely before continuing.

Step Two I apply a small patch of dry ultramarine blue to a piece of frosted acetate. (See page 21.) With a small round brush dipped in clear water, I pick up blue from the "palette" and carefully paint the design on the plate; then I let the area dry completely. Next I mix equal amounts of ultramarine blue and orange on my palette to create a neutral hue. To give the color a violet cast, I mix in a small amount of carmine red. Then I use a small angled brush to paint the shadows on the plate and on the lace.

Step Three For the strawberries, I first scrub scarlet lake onto my palette. With a clean paintbrush and clear water, I wet the lightest areas of the strawberries. Then I quickly apply liquefied scarlet lake to the dry areas of each berry. Where the color touches the edge of the damp areas, there will be a soft gradation of color. While the red wash is drying, I carefully fill the holes in the lace with a dry black pencil.

Step Four With a small brush and clear water, I wet the black color in the holes in the lace. Then I scrub a dry black pencil onto my palette and add clear water. With a medium round brush, I pick up the diluted color and apply it to the foreground. Next I add dry Hooker's green to my palette, liquefy the color with clear water, and paint the berry leaves with various values of green. When the painting is completely dry, I erase all my preliminary pencil lines—except the seeds of the strawberries—with a white plastic eraser. When erasing graphite, I make sure the eraser is clean by rubbing it on a rough piece of scratch paper; that ensures that I won't transfer unwanted color to my painting. (You can brush any eraser "crumbs" from your work with a soft paintbrush or a drafting brush.)

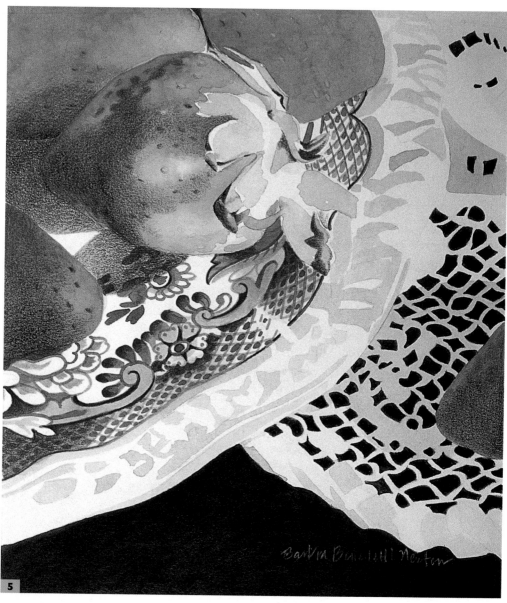

Step Five Now I work on the darkest areas. First I apply dry black and dry indigo blue pencils to the holes in the lace and in the dark foreground. Then I sign my name with a dry white pencil. Next I use wine red and indigo blue for the darkest areas on the strawberries, on the plate, and in the shadows. When I have the darkest values established, I compare them to the lightest value—the uncolored white paper—to help me determine my middle values.

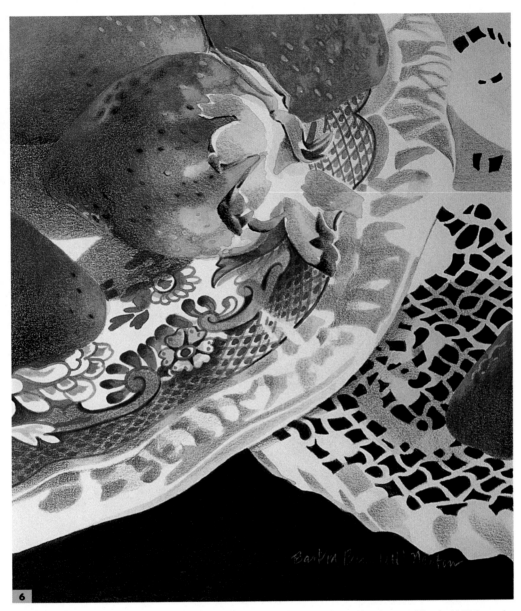

6

Step Six Next I sharpen a scarlet lake pencil and apply it (dry) over all of the strawberries—avoiding the highlights and the light seeds—using a circular strokes for consistent color. I use indigo blue, light phthalo blue, and rose madder lake for the reflections on the plate and for the shadows on the lace. Then I apply dry sap green and dry light phthalo blue to the leaves. I also apply dry indigo blue to indicate the dark seeds. Finally I use a small wet brush to pick up white and canary yellow directly from the pencils and apply the light values to the lightest seeds.

Achieving a Likeness

with Debra K. Yaun

When painting an animal portrait, it's important to capture the distinct qualities that make your subject unique, including size, shape, and expression. And if you're depicting a furry animal, that also means rendering the animal's hair accurately. When you're working with colored pencil, it's easy to create fine details. Just make sure that your strokes always follow the direction in which the fur naturally grows. And be sure to use a variety of colors to convey the texture of the fur, as Debra K. Yaun does in this portrait of a silky-haired terrier.

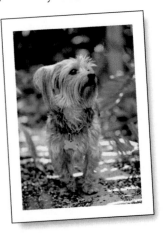

Observing Patterns I continually study my reference photo to observe the patterns in my subject's fur. I look closely at which direction the fur grows, where the colors change, and how the texture of the fur varies.

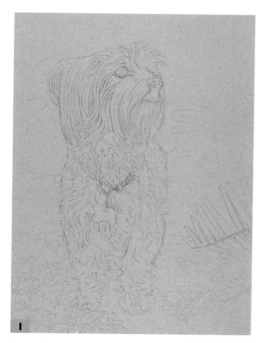

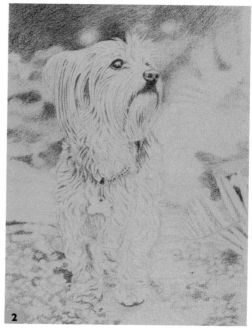

Step One I choose a piece of gold sanded pastel paper for this animal portrait for a number of reasons—it will stay flat, accept a lot of pigment, lend texture, and allow for some interesting watercolor effects. Then I draw the dog, simplifying the background in my original reference photo just a bit.

Step Two Next I apply a base of indigo to the eye, the nose, and all the dark fur areas. I also apply indigo fairly heavily to the background above the dog's head, and I indicate some textured areas on the path and in the palm frond. The roughness of the sanded paper wears down the points of the watercolor pencils quickly, so I need to sharpen them often.

Step Three Now I smooth the colors by applying water to the nose and the eye with a medium brush, leaving the white highlight in the eye. Then I wipe my brush on a piece of paper to remove some of the pigment that lifted up. Next I pull my wet brush along the fur, making strokes in the direction the fur lies. Using the bit of the pigment that's left on the brush along with a little water, I add indigo to other shadow areas of the body. I use a medium round brush to pull water across the dark area above the dog's head and the rest of the upper background. Then I switch to a smaller brush for the smaller areas and to create the textured places around the dog's feet.

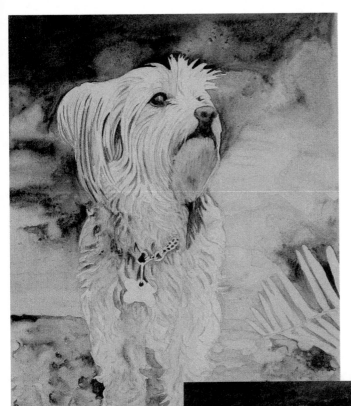

Step Four Next I apply grass green, olive green, and mineral green to the background, blending them with the indigo underpainting. I add Van Dyke brown between the palm fronds for the stem and mineral green for the fronds. Then I use indigo to reestablish some darker background areas behind the dog and to create the texture of the ground. Using terra cotta, dark umber, and a little imperial purple, I add some variation to the ground. Then I fill in the path with blue-gray.

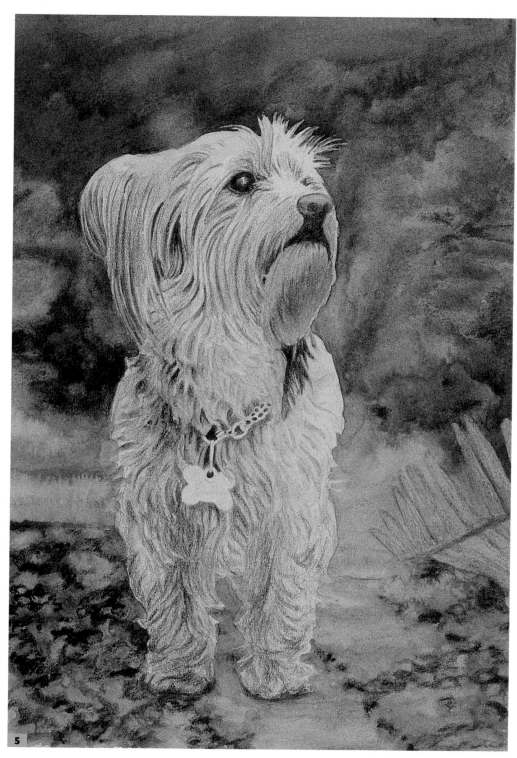

Step Five Using a medium flat brush, I add water to the top of the background and work my way down the paper. I clean the brush between colors so I don't muddy everything. Adding a little more water to the pigment that is left on my brush, I create some rock shapes at the bottom. I allow the background to dry before adding golden brown to the dog's head and body, leaving the highlight areas untouched. Then I use dark umber to add contrast in parts of the fur and reapply indigo to a few areas for deeper shadows.

56

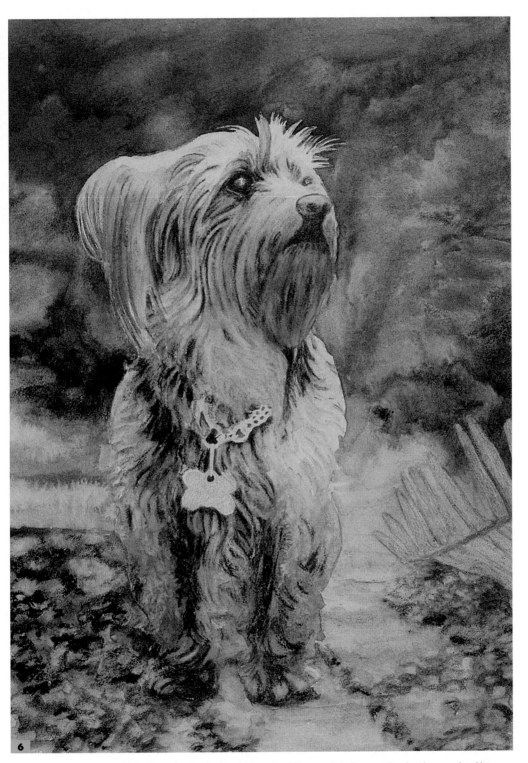

6

Step Six I continue to add details to the fur, varying the lengths of the pencil strokes, overlapping them, and making them thicker where they're close to the body. I place my pencil firmly on the paper, drag it in the direction I want the fur to go, and pull up. I try not to end the stroke with the point on the paper; lifting up gives the fur tapered, wispier ends. Then, using a small brush, I carefully pull water across small sections of the fur. I apply goldenrod to the tag, blue-gray to the chain, and true blue to the collar. I also add a little olive green to the palm frond and brush clean water over the fronds.

57

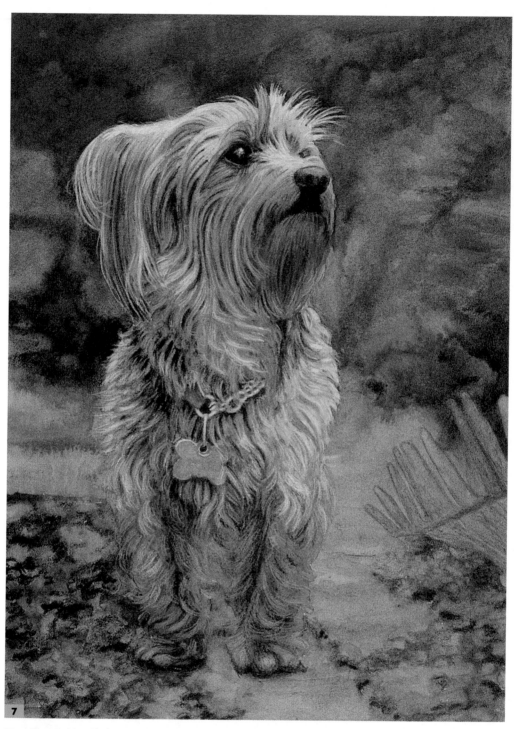

Step Seven Next I apply golden brown to indicate some light coming through the foliage in the background. I lightly apply black to the nose and dark brown to the eye. I also use a little peacock blue in the highlight of the eye and nose; then I add some white to brighten the highlight by dipping the tip of the white pencil in water and dabbing it on. I start adding highlights to the fur by applying white strokes in the direction the fur grows. Then I apply flesh pink, raw sienna, and golden brown to the areas along the highlights in the fur. I create the detail on the tag with golden brown, and I add ultramarine blue to the collar. Then I work my way down the dog's body, layering fur with raw sienna and white.

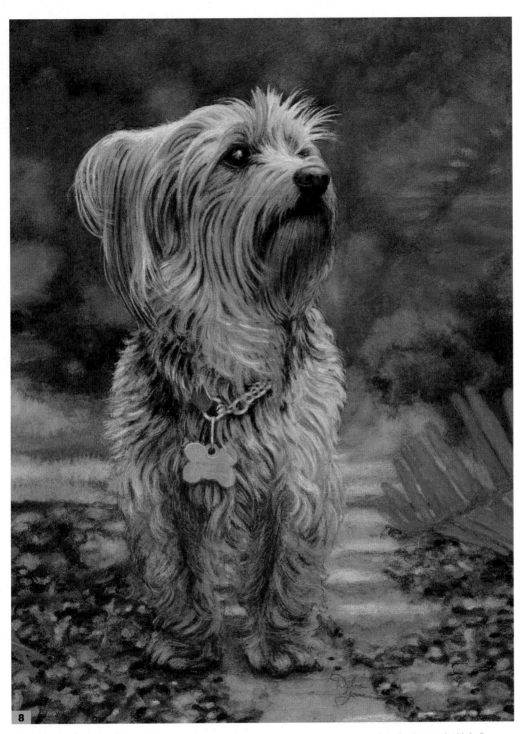

Step Eight Now I add some shadows underneath the dog and even out some areas of the background with indigo. Then I add raw sienna, blue-gray, and olive green to the background, and I add black and chocolate brown to the ground. Using a small brush, I apply water to a few of the areas in the foreground. Then I apply white behind the dog and into the ground beneath him to show the streaks of light coming through the dense foliage. I add a little color to the fur with a few strokes of terra cotta and brighten a few medium-toned areas with goldenrod. Then I use olive green to add a few leaves in the foreground to help balance the composition. Finally I add some black and chocolate brown to the mouth using a few strokes of raw sienna to soften the side of the dog's muzzle.

Combining Techniques

with Pat Averill

By now you're familiar with many of the effects you can achieve with watercolor pencil. If it's smooth coverage you desire, there are a number of ways to blend the pigment with water. And if you want to render fine details, you can accomplish that with sharp dry pencils. Once you've mastered the basics you'll be able to look at your reference and determine which techniques you should employ to render your subject accurately. And it can be fun to choose a scene that will allow you to use several techniques in the same piece, as Pat Averill demonstrates in this landscape. To depict this serene shoreline, Pat uses traditional watercolor techniques (such as lifting out color with a wet brush) and colored pencil techniques (such as using impressed lines to resist color), as well as techniques that are unique to watercolor pencil (such as using a waxy blending pencil to save white highlights).

Step One Once I've done a few thumbnail sketches to establish my values and composition, I create a simple drawing on hot-press, 140-lb watercolor paper. First I plot my focal point with a cross that indicates the height and width of the ocean rocks. Then I sketch the line between the sky and trees, the shoreline, and the shape of the white water. I find it helpful to put dots on the left and right border where I want the lines to start and end. When curves are involved, I use dots to show where they rise and fall, so all I need to do is follow the dots to complete the curves. Finally I draw the moon in the appropriate spot in the sky.

Step Two To help me locate the white water, I sketch in the shoreline and my focal points—the rocks—with dark umber. I "save" the highlights in the water using a blending pencil, taking care not to smear the rocks. Next I erase the lines on the moon and fill it in with my blending pencil, starting at the outer edge. I sharpen the dark umber pencil and make a few vertical lines in the hill to show the sunlit tree trunks. Then I use a large brush to wet the sky until it has an even sheen. Next I swipe a sharp canary yellow over the bristles of my wet brush and stroke it over the low part of the sky. I reload the brush with light carmine and layer pink in the sky. Then I use

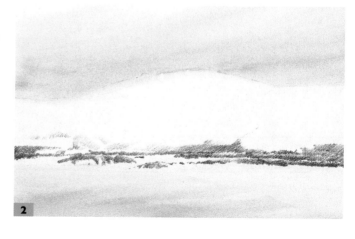

the same brush to wet the dark water. I load the brush with a few swipes of light carmine and then brush over the water again. While the color is still damp, I blot the light areas with a rag.

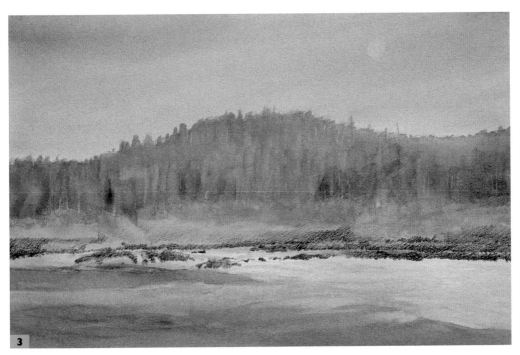

Step Three Now I carefully wet the sky again and load a damp brush with deep cobalt blue. Starting at the top-left corner, I brush the color onto the sky. Then I wet the area near the dark water and load my brush with deep cobalt blue and several swipes of canary yellow. I stroke over the water again, and then I use a clean, damp brush to lift out the white water. I use a tint of this color on my brush for the lighter areas of water. Next I use an ochre regular colored pencil to designate the top of the banks and tree trunks and go over the lightest values with a blending pencil. Then I load a wet brush with canary yellow and brush it onto the trees. Next I load a wet brush with deep cobalt blue and paint vertical lines to indicate the trees, using the point of my brush. When it's nearly dry, I add more deep cobalt blue to the shadowed areas.

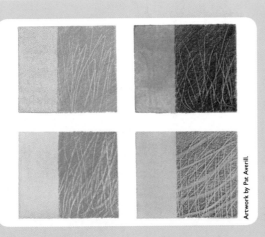

Artwork by Pat Averill.

Impressing Lines

When you impress a line in the paper, you are crushing the tooth in that area, which means no more pigment will adhere to that part. These lighter detail lines work well to depict grass or small patterns. In the gold example, a stylus is used over an initial wash to impress the fine lines; then gold ochre pencil is layered over the entire area. The blue example shows lines that were impressed with the eye end of a needle, which yields a more delicate line. You can also use the back of your fingernail to impress lines (as shown in the green example), which will create the widest impressions. The pink example shows the result of combining all three methods.

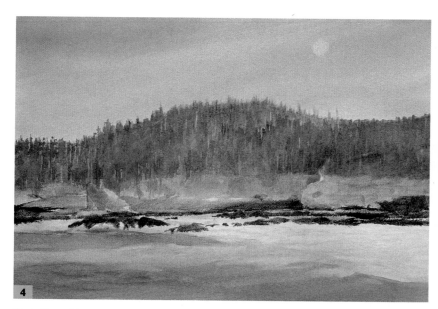

Step Four Next I create the trees with a small flat brush loaded with olive green. Then I make a pool of deep cobalt blue, light carmine, and olive green for the rocks and sand. I dip my wet brush in the mix and use the tip to create the shoreline and rocks. I borrow a touch of color from the shore and pull it in diagonally to create the sand. When everything is dry, I add some swipes of light carmine to the sand. I brush it horizontally over the banks, and then I gently brush the remaining color over the right trees.

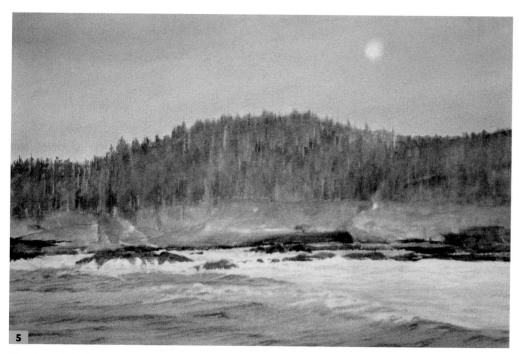

Step Five Now I use a regular light cobalt blue colored pencil to add more value to the sky. I use light pressure and then I rub the pigment in with my finger. Then I use ochre in the lowest part of the sky to create a sense of atmosphere. Next I apply light strokes of magenta to complete the sky, rubbing it in with my finger. With a plastic eraser, I remove the excess paint wherever I used the blending pencil, except on the moon; I lift off the pigment from the moon with a piece of reusable tack. Then I use light cobalt blue in the water, avoiding the "saved" whites. For the shore, I apply a sharp ochre, and then I pencil in the sunlit trees and rocks. I use a stylus and the eye end of a needle to make impressed lines for tree trunks in the background.

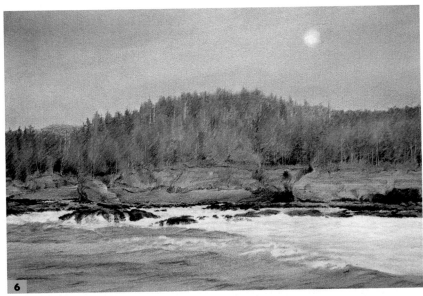

Step Six For the darks in the trees and the small distant hill on the left, I use light cobalt blue. Then I add magenta and ochre over the small hill, using right diagonal strokes and light pressure. Next I apply dark umber to establish the dark values in the rocks, the shoreline, the sand, and under the grass at the edge of the banks. I also go over the shore, sand, and sunlit rocks with ochre, using medium pressure. Then I layer ochre in the dark water with vertical strokes and light pressure.

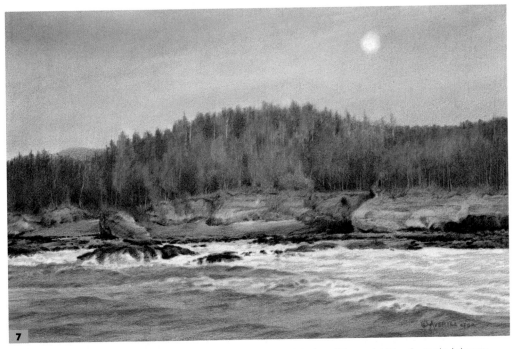

Step Seven I use magenta to go over portions of the tree trunks so it looks as if the sun is hitting the trunks. I also use magenta to go over the dark umber at the edge of the shore. Then I fill in all the sand but the lightest areas of the shore, lifting unwanted color with reusable tack. I add some magenta over the darkest values in the rocks and in the water. To fill in the rock shadows and dark shoreline rocks, I use a sharp light cobalt blue with right diagonal strokes and medium pressure. Then I use dark umber over the darkest part of the tree shadows. I touch up the water one last time with a mix of light cobalt blue, magenta, and ochre. Finally I add a touch of ochre to the sunlit water with loose right diagonal strokes.

Conclusion

Now that you've seen what you can achieve with watercolor pencil, we hope you'll continue to refer back to this guide as you further develop your skills. The more you practice and experiment with new tools, techniques, and colors, the faster your artwork will improve. Try rendering new subject matter too—remember to take pictures of any locations or subjects you deem interesting, so you can build your own reference file to peruse whenever you're ready to start a new piece. And when you travel, it's always a good idea to bring along a small sketchbook and your watercolor pencils so you can quickly render anything that inspires you. Above all, have fun working with watercolor pencil!

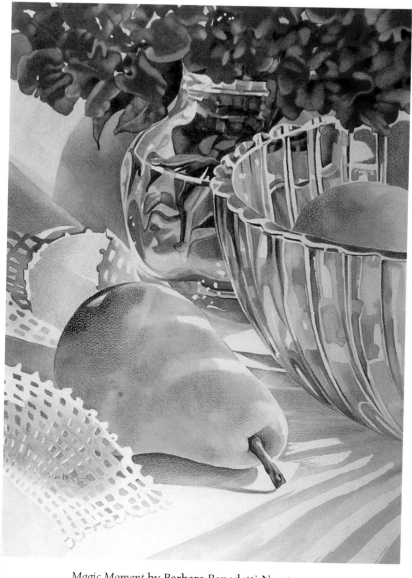

Magic Moment by Barbara Benedetti Newton

Made in the USA
Middletown, DE
10 March 2023

26505092R00038